No-Fail Watercolor

The Ultimate Beginner's Guide to Painting with Confidence

Mako, founder of makoccino

PAGE STREET
PUBLISHING CO.

Copyright © 2020 makoccino

First published in 2020 by
Page Street Publishing Co.
27 Congress Street, Suite 105
Salem, MA 01970
www.pagestreetpublishing.com

Distributed by Macmillan, sales in Canada by The Canadian Manda Group.

24 23 22 21 2 3 4 5

ISBN-13: 978-1-64567-154-1
ISBN-10: 1-64567-154-2

Library of Congress Control Number: 2019957316

Cover and book design by Molly Gillespie for Page Street Publishing Co.
Photography by makoccino

Printed and bound in the United States

To everyone who is afraid of failure.
Remember, everything is a valuable
experience. Nothing is wasted, but it's
a waste to do nothing at all.

Contents

Introduction

The Beauty of Watercolors

I love that watercolors teach you three main things: to let go, to focus on the process and to adapt along the way.

The thing is, sometimes we want to control absolutely everything in life. Before we even start a project or want to do something new, we overthink and overplan. Then, because we don't know how things will turn out, since we can't really control them, we get scared and call everything off.

The same goes for starting to learn how to paint with watercolors. A lot of false beliefs and myths are holding people back from continuing their watercolor journey or even beginning.

You might keep telling yourself stories about how:

- You don't have a background in art.
- Watercolor painting is the most challenging medium because you can't really control it or fix mistakes.
- You're simply not talented enough because you've failed in the past.

Maybe you're afraid to waste your art supplies because you worry that your artwork won't be "perfect." Or maybe you're secretly scared to fail, so you avoid it.

The truth is that watercolor painting is a skill everyone can learn! You just need to stop being so hard on yourself and start controlling the way you approach it!

Just like with cooking, you're not born with a unique talent that tells you exactly how to make the perfect pancakes, right? You learn about different ingredients, how you'll need to prepare the batter, how to make the pancakes fluffy and the ideal timing to flip them over.

Let me tell you, my first attempts at cooking were disasters! Did I think I was a failure just because all the pancakes fell apart and I set off the smoke alarm? No! It only meant I needed to adjust what I was doing! Did I give up on learning how to make pancakes altogether? No! My love for eating them was too strong to simply give up, duh! Spoiler: Now I make the best pancakes ever, if I do say so myself.

It's the same way with watercolor painting. You learn about the tools, try out different techniques and things still might not turn out the way you want them—even if you follow the instructions. But that's okay and part of the process. You try, learn and adjust. Because there are no failures, only opportunities for you to learn and grow!

The water in the cooking pot is about to boil over: You change the settings or remove it from the stove. Your watercolors start to spread out too much: You take a tissue or a damp brush to soak them up.

Having the perfect idea and planned-out process is sometimes not enough. Things happen, and you need to learn to adapt, just like in life. And that's okay! That's part of the journey!

The more you practice and give yourself permission to play around with this medium without worrying about what others might think, the more fun you'll have along the way!

Your watercolor painting isn't about creating a "perfect" painting. It's all about focusing on the present moment, enjoying the process and, most importantly, enjoying yourself!

How to Use This Book

Painting with watercolors doesn't have to be complicated or difficult—only if you make it so!

To keep things simple, I'll first walk you through the essential watercolor supplies you'll need to set yourself up for success. My motto is "quality over quantity." Who doesn't want to save money while seeing amazing results?

Then you'll learn how to mix your watercolors and what colors to choose for your painting.

Creating a colorful and vibrant watercolor painting isn't particularly difficult or complicated, but there are a few things you want to keep in mind when you choose your colors and mix them together. And that's exactly what we're going to talk about!

Remember, you don't need to have the exact same tools and colors that I show you in this book. Because there are so many different brands you can choose from, I'll tell you generally what to look for and how to make informed decisions when buying your watercolor supplies.

Having the right tools and knowing how to use them will give you not only more control, but it'll also give you a lot more confidence whenever you start a new painting!

Sometimes looking at someone else's art can make you feel overwhelmed. You might think, "It looks so complicated; I'll never be able to do this!"

The thing is, even the most complicated-looking piece starts with the same fundamental techniques and key elements as it gets created layer by layer.

Because so many possibilities of what you can paint with watercolors exist, it's impossible to cover everything! To give you an idea of what's possible, I'll cover some of the basic watercolor techniques and show you how you can use them to create various paintings using different landscape elements. If you need more painting ideas or resources for your watercolor journey, check out the "What to Do Next" chapter inside the book on page 161.

There are many different ways you can paint with watercolors, from the traditional approach to more modern ways of painting. The goal is the same: to capture the beauty that surrounds us and to express ourselves in our own unique ways.

Use the techniques and ideas that I show you in this book to get familiar with watercolor painting (I mean, you need to start somewhere, right?), and then you can expand on that! Most importantly, give yourself permission to play, experiment and have fun as you learn without judging yourself! You'll be surprised at what you're capable of!

Have fun!

Mako

Essential Watercolor Supplies

Buying watercolor supplies can be super overwhelming, right? While you don't need a lot of different things to start out with, the supplies you choose to buy can make the difference between loving watercolors and being discouraged by them. One of the reasons why most watercolor beginners get frustrated and quit is because they think they're not talented enough! In reality though, they chose the wrong supplies! I don't want this to happen to you!

Remember, it's all about being aware and knowing what to expect. If you're completely happy with the supplies you're using, that's amazing! But if you're getting frustrated because your paper is breaking, the paint won't mix or because you can't make specific watercolor techniques work, know that it's not your fault! It simply might be time to look into better supplies. Become their master and not their victim!

Watercolor Paper

One of the things that watercolor beginners usually don't pay much attention to is the paper they're buying. When you're a beginner and want to have a fulfilling experience while you learn, you want to make it as easy as possible for yourself! Good-quality paper will help with that.

You might think, "But I'm a beginner! I first need to get good before I can use good-quality supplies. I don't want to waste good paper with art that I might not like." The problem with that way of thinking is that you might never reach the point at which you feel good enough because you're always frustrated with your results. You might try different watercolor techniques and painting ideas by following tutorials but only get disappointed and discouraged because they didn't work out as you hoped they would. You might start to think it's all your fault and that you're not talented enough, when it's actually the paper that didn't allow you to succeed.

If you think about it, watercolor paper is the foundation of your painting. If you use low-quality paper, even if you have expensive watercolor paints, the colors will look a lot paler. The paper will also buckle, and the paint will dry with streaks and blotches, so you'll have to constantly fight the paper. Low-quality watercolor paper also won't be able to handle all the brush strokes and moisture. It can start peeling and breaking during the painting. And these are just a few struggles you might face when working with low-quality paper. Sounds frustrating, right?

Good-quality watercolor paper, on the other hand, is a lot more durable. You can really take your time refining your artwork layer by layer. It also makes the paint dry evenly, while keeping the colors looking vibrant. Good-quality paper actually helps you to create a better painting, and makes the learning process more enjoyable.

Buying good-quality watercolor paper doesn't have to break the bank. You can get most water-color paper in different sizes and packages, such as pads, blocks, loose sheets, sketchbooks and other types. The cheapest and most versatile way to buy good-quality paper is to buy it in sheets. You can cut them to any size you want! Cutting the paper into smaller sizes can help you feel less overwhelmed, especially if you feel intimidated by a big blank page. Then you only need to use tape to mount your paper to your desk or to a water-proof board.

How Do You Identify Good-Quality Watercolor Paper and Choose the Right Paper for You?

FIBERS

First, look into the materials the watercolor paper is made of. Watercolor paper can be made out of wood, cotton or other materials. You can find this info on the package of the paper.

Paper that's made out of wood fiber is usually cheaper, but it has lots of downsides. It's naturally more fragile and can tear easily because of the fiber's structure. This means that you can't paint for too long without the fibers loosening and start-ing to peel off. It also won't allow the water to flow properly, creating streaky and blotchy results. Also, some watercolor painting techniques are hard to achieve or simply impossible on such paper.

Paper that's made out of 100 percent cotton is considered the best paper. Cotton is stronger and more durable because of the structure of its fibers, and this means it's a lot more difficult to overwork in comparison to wood-pulp paper. Cotton paper can handle different amounts of water and drying stages at the same time, so you can achieve evenly dried layers of paint without unwanted blotches. You also want to make sure that the paper is acid free, as this type of paper resists yellowing and deterioration over time.

SIZING

Apart from the fibers, another important indicator of the quality of the watercolor paper is its sizing. Sizing is added to paper, either internally or exter-nally, to prevent mediums from absorbing into the paper fiber, causing bleeding and feathering. When watercolor paper is produced, it's traditionally sized with a coating of gelatin, starch or other synthetic materials, which improve both surface strength and water resistance.

The goal of the sizing is to keep the paint on the surface of the paper and let it slowly dry there, instead of being absorbed immediately, making the colors look dull. Sizing allows the wet paint to seep slowly into the fibers, creating vibrant and even colors. If there were no sizing on the paper, the watercolors would be absorbed by the paper like a paper towel, which is what usually happens when you use paper that is not meant for watercolors.

Sizing also makes the paper more durable. It allows you to lift off the wet paint without staining the paper, so you can easily fix individual areas in your paintings.

WEIGHT

One of the differences between regular printer or drawing paper and paper meant for watercolors is paper weight. It's not an instant indicator of quality because light and heavy paper come in different qualities; however, it's still essential because heavy paper can absorb and hold a lot more water without buckling like regular paper. The heavier the paper, the more water it can hold. That's why you want to work on paper that is no less than 140 lbs/300 gsm. If you want to have minimum buckling, you can also go for 300 lbs/640 gsm. You can try paper, for example, by Arches or Saunders Waterford if you want to use paper with durability.

Different Types of Surfaces

Now that you know what to look out for in terms of quality, what watercolor paper texture should you go for? You can get watercolor paper as cold-pressed, hot-pressed, and rough. Cold-pressed paper is one of the most popular papers because it's so versatile. It's great for wet-on-wet techniques because the little dimples hold the water and give you more time to paint.

Hot-pressed paper, on the other hand, has a super smooth surface. It's great for detailed and delicate artworks because any texture might make the lines look fuzzy. But because it's so smooth, it dries a lot quicker than cold-pressed paper.

Rough paper has a very heavy texture, and because of that, it can hold a lot more water. It's not suitable for delicate paintings, but you can use it for more abstract art or if you want to add texture to your artwork.

As you can see, there are a few things to keep in mind when it comes to choosing paper, but at the end of the day, it's always a personal choice. Every artist has their own preferences because it always depends on what paper fits best for their particular way of painting. I personally like using lots of water and paint in my artwork and being able to work on a piece as much as I want to without the paper breaking. That's why choosing a durable and heavier cold-pressed paper made out of 100 percent cotton is critical for me.

To create the projects in this book I used cold-pressed watercolor paper by Arches, Saunders Waterford and Hahnemühle Expression, all 100 percent cotton paper.

On your watercolor journey, you might discover that you'd instead prefer a more illustrative or abstract style. If this is the case, then you don't necessarily have to use a lot of water and paint in multiple layers. You can simply pick hot-pressed watercolor paper by any good brand and it will allow you to create small details with ease.

Now, remember, you don't always have to use the highest-quality watercolor paper. If you're afraid to waste your good paper, and this is the only thing that is holding you back, there are a variety of different brands and qualities you can choose from! Lots of online art stores offer an easy solution for that, and even ship internationally.

If you don't know what paper is best for you, there are different options available. You can either order a few different sheets of watercolor paper from different brands or just a few samples. This way, you can get familiar with different brands, textures and qualities before committing to a watercolor paper of choice. Just remember that with some lower-quality paper, you won't get the same results. But as I mentioned earlier, if you ever feel frustrated that you can't get your art to the next level, consider using higher-quality paper. You'll see a huge difference!

Watercolor Brushes

Next to the quality of the watercolor paper, the brushes you're using for your painting play a significant role in the success you'll have with watercolor painting.

Choosing the right watercolor brush can feel super overwhelming. There are so many different brands, sizes and materials. You run the risk of accumulating a huge set of brushes that you don't even know how to use or of a quality that doesn't satisfy you.

Even though there are so many different brushes, don't feel like you absolutely need everything. When you first start out, you will probably want to get the most out of your money, right? So starting with just a few good-quality brushes that are versatile can be a game-changer!

How Do You Identify a Good Watercolor Brush?

A watercolor brush consists of three main things: a handle, a ferrule and bristles.

The handle of a brush is not only necessary because you hold it as you paint—it also gives you a lot of information about the size, brand, series and sometimes even the shape of the brush. The handles are usually made out of plastic or wood, which can also be coated with a varnish. With some cheaply made brushes, you will run into the issue of the varnish chipping over time, which might end up falling into your painting while you're working on it.

On top of the handle is the ferrule. It's usually made out of metal and holds the handle and bristles together. The bristles that are on top of the ferrule are divided into the tip and the belly. The bigger the belly, the more water and pigment the brush can hold. The pointier the tip of a brush is, the easier it will be to paint fine lines and details. Brushes of poor quality usually don't have a fine tip. This makes it difficult not only to control the shape but also to create details, making the brush less versatile than it could be.

A good-quality watercolor brush acts like a sponge that can soak up and hold a good amount of water and paint, so you don't have to stop to load your brush with paint after every stroke. This allows you to cover a large area in one go.

The most common watercolor brushes can be divided into two different categories:

- Round brush
- Flat brush

They're called round or flat brushes because they have either a round or flat ferrule.

The bristles of a round brush have a fine point and are usually more full at the belly, which helps to store a good amount of water.

A round brush allows you to paint in a variety of stroke widths—from super-thin to broad. You can also use it to fill in big areas with paint and water, making it a very versatile brush.

The round brush also comes in different sizes. It can be small or large. If you're starting out and want to create smaller pieces of art, a size 6 or 8 round brush with a fine tip would be perfect for that. But keep in mind, the size of a brush is not universal. This means that one number that is used by one brand and series can be a completely different size for another brand and series. This is especially true when it comes to mop brushes. The main difference between a regular round brush and a mop brush is that mop brushes usually have bigger bellies and don't necessarily need to have a super-fine tip. That's because the primary purpose of a mop brush is to fill a large area with paint or water.

Compared to round brushes, flat brushes have a flat ferrule and flat bristles. They are not only great for straight, thin lines, large, broad strokes and details, but they are also great for covering large areas with paint or water. They come in various different sizes and shapes.

The ability to hold a lot of water and pigment not only depends on the size of the brush and its belly, but it also depends on what material was used to make the bristles. They can be made out of natural and synthetic hair.

Watercolor brushes with natural hair tend to hold more water compared to those with synthetic hair. They also tend to release the paint more slowly and evenly. Synthetic hair usually has a very smooth surface. Compared to that, natural hair has a texture, similar to scales, which collects and holds the water. But these types of brushes are not only more expensive and need a lot more love and care, but they're also usually not cruelty-free.

If this is something that's important to you, there are a lot of different options! Nowadays, brands release more and more watercolor brushes with bristles that imitate the real hair. The bristles are synthetic, but because of their hair-like texture, they can absorb and hold a lot more water in comparison to regular synthetic brushes.

Similar to watercolor paper, what brushes would work best for you depends on what you want to paint. The general rule is, the bigger the area you want to cover in paint, the bigger the brush should be. I personally like to use a medium round brush with a fine tip that can hold a lot of water and paint. This gives me the ability to cover a relatively large area of the paper with paint or water, but at the same time I can use its fine tip to add fine lines and details. If I quickly want to cover a big area with paint or water though, I also like to use a big, flat brush. Once you've become familiar with the basic techniques and want to expand your brush collection for specific techniques, you can always buy additional brushes.

To create the projects in the book I used only two brushes: one round Silver Black Velvet brush in size 8 and a da Vinci Fit synthetics in size 20mm.

How to Take Care of Your Brushes and Store Them

To make your brushes last a long time, it's essential to take good care of them—especially if you just invested in good-quality watercolor brushes. During and after your painting process, you want to keep a few things in mind:

First of all, don't leave your brush inside your water container. Keeping it in water for too long can weaken the glue that holds the bristles and the brush together, so the brush might start losing hair. Most importantly, this can ruin the shape of the bristles because the whole weight of the brush will bend and deform its shape. Instead, place them horizontally on your desk or on top of your watercolor box.

Now luckily, with watercolors, we don't really have to worry about the cleaning process too much because watercolors are water-soluble. This means you only have to rinse your brush with clean water to remove the paint and you're almost done. Soak up the excess water with a tissue or paper towel and reshape the tip of your brush between your fingers to get a fine tip to make sure the brush dries in the right shape.

Once your brush is clean and the tip is reshaped, you want to store the brush either horizontally or hung with the bristles pointing downward and not touching anything below. If you let your brushes dry vertically with the bristles pointing up, the excess water will sink under the ferrule, which again, over time, will weaken the glue that holds the hairs in place.

When the bristles have thoroughly dried, make sure you store the brushes in a way that doesn't put any pressure on the bristles. You can store the brushes in different ways: You can place them flat inside a drawer, making sure they don't bump into anything with their bristles. You can also put them in a jar or other container with the bristles upright. Never let the brushes stand on their hair though—always stand them on their handles—this way, your brushes will have a long, happy life!

Watercolor Paint

Nowadays there are so many different watercolor sets, brands and colors you can choose from. This can be super-overwhelming when you're just starting out. I know it's tempting to buy a set with fifty different colors that are cheaper than a small set with twelve paints, especially when you see all the pretty colors. With this many different colors though, it's easier to create muddy results. Plus, the quality of the paint will most likely not be that great either.

How Can You Identify What Is Good-Quality Paint?

Watercolors are made from pigments, binders and different additives. The amount and quality of these ingredients define the quality of the watercolors. Super cheap watercolors, for example, usually have a lot more fillers than actual pigments. Those fillers are used to stretch the amount of paint, which is why cheap watercolors can look a lot more opaque, chalky and streaky. Usually those types of paints also don't give you any details about the pigments, how transparent they are or how they behave when exposed to light.

If you've struggled with your watercolors in the past or if you want to set yourself up for success, look for brands that share all the information about their paint—from what makes up their color to their characteristics. For example, they may specify what pigments are used, the pigment number, what their level of transparency is and how staining they are.

The thing is, you don't have to go for the most expensive watercolors! Most known brands carry student- and professional-grade watercolors. The only difference is the amount (and sometimes the type) of pigment they've used to produce their paint. You can invest just slightly more to upgrade from the chalky, cheap paints made for children to higher-quality brands. They'll make your life easier and your watercolor painting experience so much more fun!

The good news is that you don't even need a ton of different colors! You can mix anything you want with just a few basic primary colors, and this is what you're going to learn later in this book!

Pans vs. Tubes vs. Liquid

Watercolors usually come in pans (cakes), tubes and in a liquid form.

PANS

Watercolors in pans are made out of pigments, binders and different additives and come in small plastic pans. You can get them in half and full pans, either in a set or individually. If you buy a set of watercolor pans, they usually come with a mixing palette and are ready to go. They only require a little bit of water to be activated right in the pan, making them great for traveling. Pans are great for beginners because they're compact and easy to use.

To activate the paint, add a little bit of water on top of the paint to pre-wet it. This way, it's easier to pick up the pigments. Since you need to go back and forth to get as much paint as needed for the painting, it can take longer to prepare the right amount on your mixing palette. Because of this, it can be more challenging if you want to create a bigger project, as it will take a lot more time to prepare the paint. But at the same time, you will only use as much paint as you actually need.

Even though watercolors in pans are easy to use, if you use them a lot, you can run out of paint really quickly. This is because they contain a lot less paint in comparison to watercolors in tubes, so pans can become more expensive in the long run versus tubes. But if you do run out of paint, you can either replace them with a new pan or fill the empty pan with watercolors from a tube and let them dry there. This way you can even create your own customized watercolor palette.

TUBES

Watercolors in tubes are a more cream-like form of watercolors also made out of pigments, binders and additives. Like watercolor pans, you can buy tubes in different sizes in a set or individually. Since a lot of watercolor tubes don't come with a palette, you will need a mixing palette with wells and a mixing area. Plastic tends to repel water and paint, so it's more challenging to create the desired paint-to-water ratio, as the paint tends to create beads inside the palette. As an alternative, you can use porcelain palettes with several separate wells.

With tubes, it's more challenging to decide how much paint you'll actually need. Some beginners tend to use them like acrylic paint or have trouble with how pigmented the colors are, so they can easily waste paint. But compared to the pans, they're great for larger paintings because you can mix a lot more paint much more quickly. But at the same time, it can be harder to judge how much paint you actually need. Even if you don't use up all the paint in one go though, don't worry! You can always reactivate the dried paint with water.

LIQUID

Liquid watercolors are a lot more vibrant than watercolors in tubes or pans. Since they are already liquid in a big bottle, it's easy to use a large amount of paint and adjust the intensity by adding water to the mixing palette. Compared to watercolors in pans and tubes, most of these types of watercolors are dye based, and the colors can fade quickly over time when exposed to light. This is because they're usually made for paintings that are intended to be scanned afterward. Since they are dye based, they stain the paper, which will prevent you from using specific watercolor techniques such as lifting (page 35). This means that if you want to remove the paint from a certain area on your paper, they will leave a stain and not reveal the white again.

I personally like switching between watercolors in tubes and in pans. Whenever I want to quickly test an idea or don't really need a lot of paint, I use pans. But if I want to paint a larger painting or simply need more of a specific color, I use watercolors in tubes and a porcelain mixing palette. If you're just starting out, using watercolors in pans might be an easier solution for you. This way you can take the time to get really familiar with your colors, mixing them until you know exactly what colors you need the most. Then you can purchase those colors as a tube when you want to restock your selection!

To create the projects and color charts in this book I used different brands from my collection of paints. I rotated between Schmincke Akademie/Horadam, a Winsor & Newton Cotman set and a Van Gogh Pocket Box. All of these are great watercolor painting pan sets for beginners to start with!

Other Essential Materials

After paper, brushes and paint, you'll need a few other essential tools.

Water Containers

To make sure your colors stay vibrant during your painting process, it's essential to use clean water. If the water is dirty, it will make your colors look muddy or change them completely. This is especially true when it comes to yellow colors!

The easiest way to keep your colors as clean and vibrant as possible is by using two jars of water: one jar for rinsing your brush, the other jar for loading up your brush with clean water. Once you've rinsed your brush, squeeze the bristles with your fingers above your rinsing water. You'll be surprised how much paint is still in your brush! This way you make sure that your brush is as clean as possible. After that, use the jar with the clean water to load your brush when switching between colors or when you simply need to apply clean water onto your paper!

Paper Towel

In watercolor painting, you have to deal with lots of water. That's why you want to use a paper towel or tissues to control the amount of water on your paper and on your brush. You can use them to remove excess paint or water on your brush and paper, but also for various different watercolor techniques such as lifting (page 35)!

Masking Fluid

Masking fluid is a great tool to help you protect your white paper from paint. Instead of carefully painting around an object, you can use masking fluid to preserve this area while you paint everything else. It's also a great way to keep small highlights that are more difficult to paint around. When the paint is dry, you can remove the masking fluid to reveal the white paper again. It usually comes in a jar with a screw-on lid and you simply apply it with a brush, just like your paint. You can also find bottles with an attached needle on top, making it possible to create fine lines and details without any additional tools. I also sometimes prefer to use a masking fluid that is slightly tinted (for example, it appears as a pale blue in the paintings in this book). This way I can clearly see where I applied it when I paint! But it's up to you and you want to experiment!

Note: Make sure to test out your masking fluid first. Depending on what fluid and paper you're using, you can have different experiences. One of the most important things to keep in mind is that you want to let it dry naturally—so don't use a hair dryer to speed up the drying process, as it will be difficult to remove the masking fluid later. You will also have difficulties when you apply it onto wet or damp paper, as the paper will absorb the liquid, making it impossible to remove later without damaging the paper. You also don't want the fluid to stay on the paper for too long, so when you're done with your painting, remove it. I also wouldn't recommend using any of your new or high-quality brushes to apply masking fluid. Use one of your cheap brushes and clean it right afterward!

Masking Tape

If you use loose sheets of paper, using masking tape to mount the paper to your desk or board helps keep the paper in one place and prevents the paper from buckling too much. Another benefit of masking tape is that when you remove it later, you get a crisp white frame around your painting, making your artwork stand out more! I personally like to use washi tape or tapes made for sensitive surfaces.

Note: To make sure that the tape doesn't rip your paper when peeling it off, you have a few different options. One of my favorites is using a hair dryer. If your tape turns out to be super-sticky, use a hair dryer to slightly melt the sticky part beneath the tape. This way you can easily peel it off. Another way is to peel the tape away from your painting—meaning that instead of peeling off the tape along the edge downward or to the side, you peel it off in a 90-degree angle perpendicular to the edge the tape was securing.

Hair Dryer

If you don't have much time to wait for the paint to dry, you can use a hair dryer. Just make sure that the paint it not too wet (there are no puddles of water on the paper). Then, using medium heat and power, carefully dry the paint.

White Gouache

White gouache is an excellent addition to your watercolor set. You can use it to add white highlights or details, but you can also mix it into your watercolors to make the colors opaque. This way you can add even more accents on top of your watercolors to make the painting come together!

Sponge

Painting with a sponge can also add interesting and unique textures in your paintings. You can usually find a selection of sponges in different sizes and made from various materials made especially for painting projects. For the projects in the book, I'm using a synthetic sponge from a set of different watercolor sponges.

Pencil and Eraser

Depending on what you want to paint using your watercolors, an HB pencil and a soft eraser can be great tools as well. You can use a pencil to create a few guidelines to structure your painting area or to create a loose sketch.

Note: Remember to only lightly sketch out any guidelines without pressing down on your pencil too much, otherwise you might damage the paper. If you don't want any pencil lines to be visible later, don't forget to lightly erase them. To do that, use a soft eraser so as not to damage the paper before you apply the paint. Once you paint over the pencil marks, you can't remove them. An alternative to that is to use either water-soluble graphite or colored pencils. Once you paint over these, the pencil marks will dissolve in water!

The Art of Watercolor Mixing

The Color Wheel

You might have heard that there are three primary colors (red, blue and yellow) and by mixing them you can get the secondary colors (orange, purple and green).

But this is a simplification that can lead to frustration. "Why does my purple or green always look so dull and muddy?" This is one of a few common questions you might ask yourself all the time as a beginner.

Red, blue and yellow are just overall terms covering a variety of different types of reds, blues and yellows. If you've ever looked at a watercolor set, you might have also wondered why there are so many different yellows, reds and blues. You might not even like red, and you just paid for two!

Paint pigments aren't completely pure colors. Having different reds, yellows and blues in your watercolor set allows you to mix a variety of different colors. Depending on which of these primaries you mix together, you'll either get a vibrant mixture or a more dull version. Which one you prefer will depend on what you want to paint and what you like! And you want to be in control of that!

How Do You Identify Their Differences?

Let's begin from the start!

The basic theory behind color mixing is that with the primary colors—yellow, blue and red—you can mix the secondary colors—green, purple and orange. And if you mix the three primary colors together, you get brownish to grayish mixtures depending on their ratios because they neutralize each other. This is one of the ways you can create different grays and blacks.

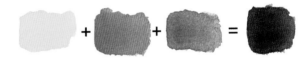

If you mix a secondary color with additional amounts of one of the primary colors that make it up, you can get the tertiary colors—yellow-green, blue-green, blue-purple, red-purple, red-orange and a yellow-orange. You only adjust the amount of the additional primary color you add to the mix.

With all these colors, you can create a color wheel. The colors that are across from each other on the color wheel are called complementary colors. This means that, if you place them next to each other, they will enhance each other's intensity. But if you mix them together, they neutralize each other and create gray or brown—depending on the amount of each color.

This is important to know because sometimes you might find that, for example, one of your greens is way too vibrant. In this case, you can simply mix in a little bit of red to mute the colors. This way you get a more natural-looking version. That's because when you mix colors together that lie on opposite sides of the color wheel, you always automatically add a third primary color into the mixture. This happens, for example, when you mix green (yellow + blue) with red.

You can also divide the color wheel into warm and cool colors. Yellows, oranges and reds are considered warm, while greens, blues and purples are considered cool colors. This color temperature refers to the feeling that you can get when you look at a specific color. You can use the temperature of those colors to create the illusion of depth. You can do that by placing cool colors in the background to suggest distance and warm colors to the foreground to make objects appear closer to the viewer.

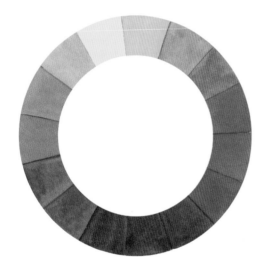

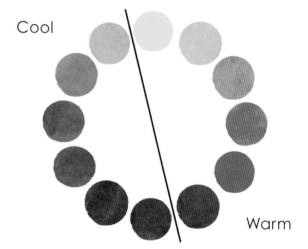

Cool

Warm

However, within those colors, there are both warm and cool colors depending on what the color leans more toward. This means that every color has a certain undertone. This gets more obvious if you place two of each primary color next to each other.

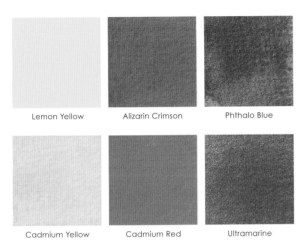

| Lemon Yellow | Alizarin Crimson | Phthalo Blue |

| Cadmium Yellow | Cadmium Red | Ultramarine |

In this example, if you look at Cadmium Yellow, you might notice that it looks slightly orange. This is because it has a hint of red in it. This red is the undertone of Cadmium Yellow, making the yellow lean toward orange and into a warm yellow color.

At the same time, Lemon Yellow looks a little bit greenish compared to Cadmium Yellow. This is because it has a hint of blue in it. This blue is the undertone of Lemon Yellow, making the yellow lean toward green and into a cool yellow color.

If you look at Cadmium Red, you might notice that it looks a little orange compared to Alizarin Crimson. This is because Cadmium Red has a hint of yellow in it. This yellow is the undertone of Cadmium Red, making the red lean toward orange and into a warm red color.

Compared to Cadmium Red, Alizarin Crimson looks slightly purplish. This is because it has a hint of blue in it. This blue is the undertone of Alizarin Crimson, making the red lean toward purple and into a cool red color.

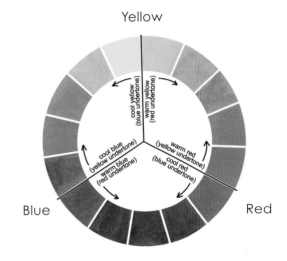

The same goes for Ultramarine. It has a red undertone, making the blue lean toward purple and into a warm blue color. Phthalo Blue has a yellow undertone though, making it lean toward green and into a cool blue color.

This is important to know because depending on what blue or red you choose to mix into a purple, you'll either get a clean and vibrant purple or a duller and more muted version. The undertone of the color will tell you exactly what colors to choose to get the desired result!

Primary colors that lean toward the same secondary color (for example, Alizarin Crimson and Ultramarine both lean toward purple) are generally closer to each other on the color wheel.

This is why most standard watercolor sets offer two of each primary color to allow you to create a variety of different colors. In addition to that, they have a few earthy colors and sometimes black or gray. This gives you even more options to play around with while getting familiar with color mixing without feeling overwhelmed! And by making your own color wheel as a guide, you can not only mix hundreds of colors with just a few basic primaries, but you also save a lot of money! From there, you can always add more colors to your collection, which will be the cherry on top!

Note: There are a lot of different reds, blues and yellows. That's why you should always keep in mind that there are no absolutes in color, as everything is relative to what you place it next to. It's important to see colors in context. While one red looks cool next to a warm red, this cool red can look warm next to another red color.

So don't stress about it too much! Compare your colors to each other and pay attention to their undertones. The important part here is to know which primary color to mix together to either get a vibrant or more muted version according to their undertones.

Try It Out!

Create two small puddles of water inside your mixing palette. Next, load your wet brush with a vibrant yellow color, for example Lemon Yellow or a similar color. Then add the pigment to the puddles to dilute the paint. Make sure both puddles of paint have about the same amount of water-to-paint ratio. You want the paint to be vibrant but

also have a rather watery consistency. Load your brush with paint, remove excess moisture from the brush by gliding the bristles over the edge of your mixing palette and paint two circles or a square next to each other to swatch the color.

To see the difference in the mixing results, you want to create two different greens, for example by mixing the yellow with Ultramarine and Prussian or Cerulean Blue. Ultramarine is a warm blue color compared to the other two blues. This means that if you mix Ultramarine with Lemon Yellow, the resulting green will look a lot more natural and less vibrant. This is because Ultramarine has a hint of red in it.

Now rinse your brush and load the tip of your brush with a little bit of Ultramarine and add it to one of the puddles of Lemon Yellow paint to mix it in. The yellow-colored paint should now turn into a more yellow-olive color. Apply the paint below the first yellow swatch to see the difference. From there, you can continue adding more Ultramarine, little by little, to make the yellow-colored paint more green. If you notice that you're running out of paint, don't worry! Simply add a little bit more water and a little bit more paint to the puddle to create a similar color and continue the steps. Remember: By adjusting the proportions between those two colors, you get a variety of different greens from more yellowish to more bluish-green colors.

Now you can repeat the same steps with Lemon Yellow and Cerulean or Prussian Blue!

Rinse your brush and make sure the bristles are completely clean. Then, load the wet brush with a little bit of the second blue-colored paint and mix it in. By mixing Lemon Yellow with Cerulean or Prussian Blue, you create a very vibrant green because you don't passively add the third primary color, red, into this mixture. Apply the paint below the second yellow swatch of paint to see the difference between the two greens next to each other. From there you can continue the steps and add more blue paint little by little until you're happy with the different greens you've created!

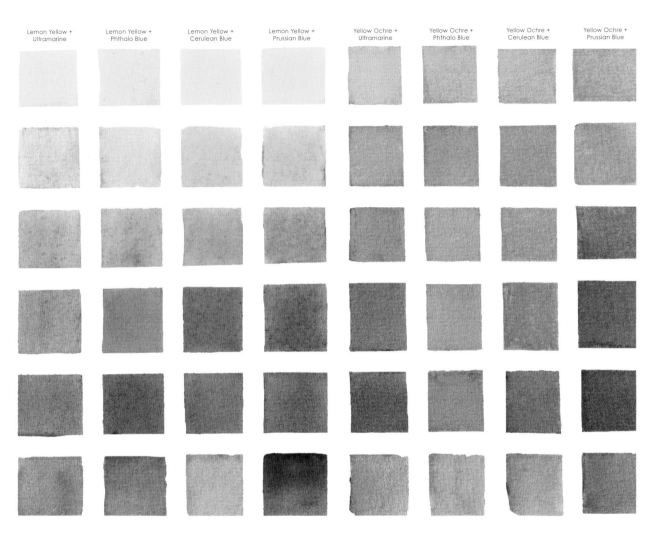

| Lemon Yellow + Ultramarine | Lemon Yellow + Phthalo Blue | Lemon Yellow + Cerulean Blue | Lemon Yellow + Prussian Blue | Yellow Ochre + Ultramarine | Yellow Ochre + Phthalo Blue | Yellow Ochre + Cerulean Blue | Yellow Ochre + Prussian Blue |

If you want to take it a step further, you can create different color-mixing charts by mixing different primaries together to see what secondary and tertiary colors you can get! This is so much fun! In this example, I only used a few basic primary colors to create different oranges, greens and purples. You can also use tape and divide your watercolor paper into multiple sections. This way you can easily cover the small squares in paint without worrying about the colors running into each other!

Isn't this fascinating? I love color mixing! At some point you'll discover what colors you like and use the most. Then you can create your own personal color palette with the colors you need!

For the projects in this book, I used a limited palette to show you that you don't need to have a ton of different colors to create beautiful art!

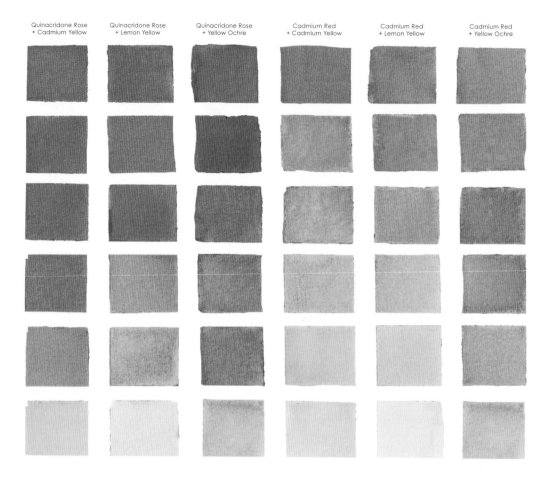

| Quinacridone Rose + Cadmium Yellow | Quinacridone Rose + Lemon Yellow | Quinacridone Rose + Yellow Ochre | Cadmium Red + Cadmium Yellow | Cadmium Red + Lemon Yellow | Cadmium Red + Yellow Ochre |

Here is an overview of all the colors I'll be using for the projects. Remember: You don't have to use the exact same colors. Try to match your colors by paying attention to their undertones. As I said earlier, you can find most colors that I'm using in any standard watercolor set. Two primaries of reds, blues and yellows, plus additional earth tones and gray are enough! They might have different names and different formulations, but that's okay! Once you're more familiar with mixing colors, you might want to dive into all the little details and learn about different pigments!

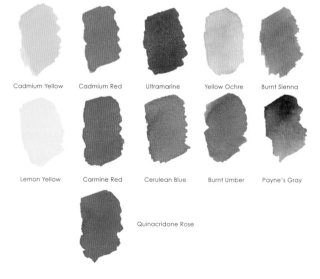

Cadmium Yellow Cadmium Red Ultramarine Yellow Ochre Burnt Sienna

Lemon Yellow Carmine Red Cerulean Blue Burnt Umber Payne's Gray

Quinacridone Rose

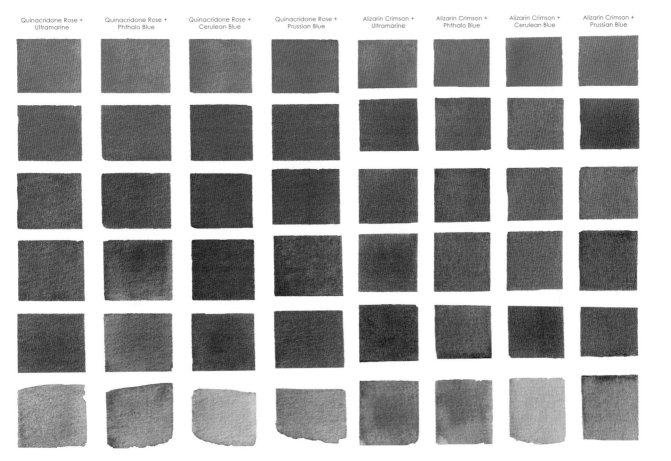

| Quinacridone Rose + Ultramarine | Quinacridone Rose + Phthalo Blue | Quinacridone Rose + Cerulean Blue | Quinacridone Rose + Prussian Blue | Alizarin Crimson + Ultramarine | Alizarin Crimson + Phthalo Blue | Alizarin Crimson + Cerulean Blue | Alizarin Crimson + Prussian Blue |

Water-to-Paint Ratio

Sometimes watercolor beginners think that the more colors their set has to offer, the more interesting their watercolor painting will be. But in reality, you really just need a few basic colors because you can unleash their full potential in just a few simple ways. The magic happens not only by mixing different colors together, but also by simply using water!

Remember, in watercolor painting, you lighten a color by adding water. So instead of using white, as you would usually do when painting with oils or acrylics, you use the whiteness of the paper instead. This is because watercolors are a transparent medium. Now some artists like to use Chinese White to make their colors look more pastel, but

this makes the color more opaque and dull when you mix it with other colors. If this is what you're going for, great! Just be aware of what happens and know that you have options!

How much water and pigment you should use to get the desired result is one of the key elements you want to get familiar with when learning to paint with watercolors.

- The more water you use compared to pigments, the lighter the colors and the more watery the consistency of the paint becomes.

- The more pigment you use compared to water, the darker the color and the creamier and more concentrated the consistency of the paint becomes.

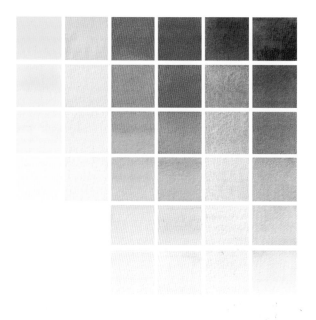

The lightness or darkness of a color is also referred to as value. Each color has a range of different values.

If you want to discover the full potential of your colors, you can create a value scale. This way, you get an overview of all the possibilities while you practice your water-to-paint-ratio skills! You'll notice that some colors don't offer a great range of values, such as yellow. Other colors that are darker, such as blue, offer a larger range of values. The projects in this book will help you practice your water-to-paint ratio skills!

TRY IT OUT YOURSELF!

Create a value scale from light to dark. You can either draw small squares on top of your watercolor paper using a pencil or you can simply apply the paint without using any guidelines. Whatever works best for you!

To be able to start with a light value first, you want to create a small puddle of water in your mixing palette. From there, dip the tip of your wet brush into a little bit of paint to load it up with pigment. Then add the paint to the puddle of water to dilute it and mix everything very well. This will be the lightest value of your color.

Now use this color mixture and apply it to your watercolor paper.

To make this value darker and darker, you want to add darker paint into the puddle little by little without rinsing off the brush. This way you make sure that you don't dilute the paint again. You'll notice that the more pigment you add to the puddle, the creamier the consistency and the darker the color becomes.

Repeat this step until you reach the darkest version of your color.

Note: If you notice you have way too much water and it takes you too long to make the color darker, simply take some of the colored water and move it to another area on your mixing palette. From there, add more pigment to this puddle of paint! This way you have less water to work with!

How to Make Colors Darker and More Dynamic

With the previous exercise, you'll notice that a color can only become as dark as its value range allows. Meaning, you can't really make a yellow color as dark as a color like blue. While you can make the color darker by using less water, you can also mix it with a darker color.

In the example on page 25, I used different colors and changed up their ratios as I mixed them together. As you can see, there is a wide range of rich darker colors.

This is also a great alternative to using black straight from the tube to make a color darker. If you experiment with different ratios, you'll see a beautiful selection of different blacks you can use in your painting. If you use black straight from the tube or pan, your painting can look lifeless and sometimes flat, so you want to be careful with that!

Sometimes colors straight out of the tube or pan can also be very intense and too saturated. This means that if you were to use some of the greens straight out of the pan or tube to paint trees, the

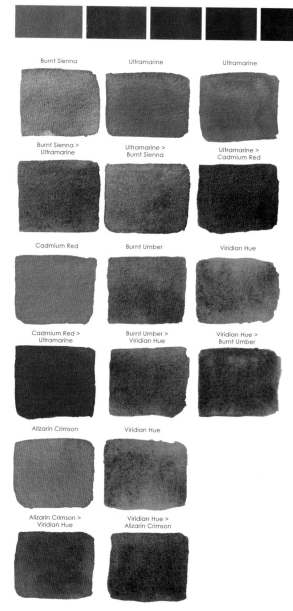

Burnt Sienna

Ultramarine

Ultramarine

Burnt Sienna > Ultramarine

Ultramarine > Burnt Sienna

Ultramarine > Cadmium Red

Cadmium Red

Burnt Umber

Viridian Hue

Cadmium Red > Ultramarine

Burnt Umber > Viridian Hue

Viridian Hue > Burnt Umber

Alizarin Crimson

Viridian Hue

Alizarin Crimson > Viridian Hue

Viridian Hue > Alizarin Crimson

leaves might look unnatural because they're too vibrant. To achieve a more natural version of that green, you want to tone it down. In watercolor painting, you usually do that by adding its complementary color. This way you can dull the green color, making it less intense and more natural. But you can also use your earthy colors, so play around with different mixtures!

TAKE OUT YOUR WATERCOLORS AND TRY IT OUT FOR YOURSELF!

Let's try mixing red and green first.

Create a small puddle of paint inside your mixing palette using any bright green–colored watercolor paint you have. Test the consistency and lightness on a piece of paper to see that it's not too watery or too dark.

From there, dip the tip of your wet brush—without rinsing it in water—into red-colored paint to load it up with pigment, and then mix it into the puddle of paint. Apply the paint next to the previous swatch of paint. You'll see that the color slightly changes. The vibrant green color should now look slightly darker and more natural.

Now you want to add more red-colored paint little by little into your green-colored puddle of paint. You can also add a little more water to the mixture if you find that you run out of paint too quickly. Just make sure to readjust the paint-to-water ratio so the color doesn't become too light! The more red-colored paint you add, the darker and more muted the green becomes. If you play around with different ratios of red and green, you can even create a very dark brown or gray!

Now you can try it out the other way around!

Create a small puddle of red-colored paint and add a bit of green little by little. You'll see what beautiful colors you can create just by using two colors!

Color Harmony

Our world is filled with beautiful colors! And their variations can do everything from conveying a message to even influencing our emotions. Color harmony is something you can see and feel. That's why it's essential to understand the basics of color. There are specific color combinations that have been established over time. These color combinations have a fixed relationship on the color wheel and are pleasing to the eyes when viewed together. They create color harmony.

At the beginning of your watercolor journey, it's very tempting to use all the colors your watercolor set has to offer, but this can make your artwork look either too busy or all over the place. Having just a few colors to work with will help you decide what colors to choose in your painting without feeling overwhelmed.

The easiest way to decide on colors for your art is to choose a color scheme using your color wheel (page 18). This is something that is overlooked a lot. Knowing how to use your color wheel and pick colors accordingly will help you create unity within your painting. But remember, give yourself room to experiment and to play around with different colors!

Monochromatic

With a monochromatic color scheme, you can easily create harmony. A monochromatic color scheme uses only one single color throughout the whole painting, but uses its variations from light to dark. This way you can make sure that you avoid color conflict. It's a very elegant, minimalistic and easy-on-the-eyes color scheme that you can use to practice using different values to create contrast in your painting. Here, the motto is "less is more"!

Analogous

An analogous color scheme is made of colors that sit close to each other on the color wheel. Because of their close relationship within the color wheel, it's easy to achieve color harmony. This way you can also avoid muddy results when these colors are mixed together, as no color can dull them down. This is also an elegant and visually pleasing color palette that you can find in nature. You can achieve contrast in your painting by using their different values.

Complementary

A complementary color scheme is made up of two colors that sit opposite each other on the color wheel. To be able to use this color scheme effectively, you want to balance the saturation of the colors, so they both support each other instead of competing for attention.

Complementary Analogous

This color scheme combines both analogous and complementary colors to achieve contrast. It incorporates three or more that are next to each other on the color wheel and one color that is a complementary color of the center color.

Triadic

A triadic color scheme consists of three colors on the color wheel that are in a triangular relationship. You can choose between triads of primary, secondary and even tertiary colors.

Primary triads are the most versatile color combination, as you can use them to create a variety of different colors from vibrant to more muted and "muddier" versions, depending on what type of red, blue and yellow you choose. To create harmony using this color scheme, you want to pick one color as the dominant color and use the other two colors to mix it into that color.

Now there are even more color schemes you can explore. In this book, you'll get familiar with the basics that I mentioned here as you practice color mixing and different watercolor techniques.

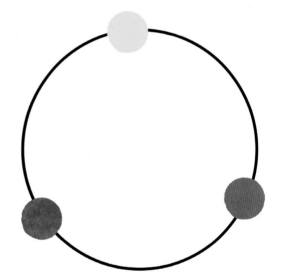

The Basic Techniques

The Amount of Water on the Brush and Paper

When it comes to watercolor painting, you want to be aware of how much water there is on your brush and on your paper, and to be in control of it.

When it comes to paper, the main stages of wetness you want to focus on for now are wet, damp and dry.

If you evenly distribute water on top of your paper to make it wet, it looks shiny and you can clearly see its texture. When you let the paper absorb some of the moisture for a few seconds, it loses a little bit of its shine as it gets damp. Now if you wait a little longer, the paper starts to dry. If you want to apply wet paint on top of dry paint, make sure the layer of paint is completely dry.

For your brush, you also want to pay attention to the amount of water it holds. The main stages you want to focus on for now are also wet, damp and dry.

Once you dip your brush into your water, you always want to make sure you lightly wipe it once or twice on the edge of your water container to make sure it's not too wet. If it's too wet, the drops of water can accidentally drip where you don't want them to be, especially during your painting process. If you simply want to distribute water or paint to a large area of paper, that's okay. The next stage is damp. If you've wiped off the water on the edge of the container, you want to remove excess moisture using a tissue or paper towel to make the brush damp. A damp brush is great for soaking up excess water or paint on the paper. When the brush is almost dry but still has enough moisture to hold a little bit of pigment, it's a great way to add texture to your painting using the dry brush technique (page 36). And if you use a clean, dry brush, you can lift off any excess water or paint to reveal the white paper below again.

This is something you want to pay attention to when learning how to paint with watercolors, so you know exactly how paint and water interact with each other on the paper.

Note: Remember, a greater amount of water will always flow into a lesser amount of water. For example, if your paper is damp and you apply wet paint on top, the wet paint will push away the drying pigments. This way, you can create backruns, also known as "the cauliflower effect" or "blooms."

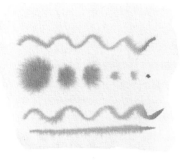

More water on the paper
than on the brush

Less water on the paper
than on the brush

Damp paper with concentrated
consistency of paint

Sometimes you want to achieve these effects and sometimes you don't. Knowing how to do that puts you more in control!

The same goes for the amount of moisture on your brush. This means that if there is more water on your paper than on your brush, the brush will act like a sponge and soak up the water. This way the pigments on your brush won't spread out on the wet paper. If there is the same amount of water on the paper and on your brush, they simply will block each other out, and you won't see much paint flow in either direction.

If you want to make the paint spread out smoothly and with control, make sure that the paper is damp and that the brush holds pigments of a creamy consistency to balance the flow.

A lot of watercolor beginners feel intimidated or are even scared to use this medium because they feel like they can't control it, but you do get to control this medium with just a few simple tricks. You just need to practice and pay attention to it, and as I said in the beginning of this book, sometimes you also simply need to let go and let the paint do its magic! Enjoy it! It's a collaborative process after all!

Now It's Your Turn to Test It Out!

Grab your watercolor brush, dip it into clean water and distribute it on your watercolor paper to create a square. Pay attention to the shine of the paper! Next, dip your brush into your paint and glide the brush over the edge of your mixing palette. To make it more dry, also dab it onto a tissue or paper towel. Now press your brush down onto the wet paper. You can create dots, lines or anything you want. Do you notice how little the paint spreads out?

Now repeat this step with more moisture on your brush! Dip your brush into paint that has a watery consistency and dab the brush onto the now damp paper. Can you spot the difference?

If there is less water on your paper than on your brush, the watery paint from your brush will smoothly spread out onto the paper.

Now perform the same test with a more concentrated mixture of paint.

This time apply water on top of your watercolor paper and let it absorb some of the moisture until it loses its shine. In the meantime, prepare paint of a creamy consistency. Then, load your brush with paint and lightly glide the brush over the edge of your mixing palette. You want the brush to be wet and loaded up with a concentrated amount of pigments. Once the paper looks less shiny, apply the paint to the paper. See how it spreads out, but with more control?

Watercolor Washes

Watercolor washes are the foundation of watercolor painting. Washes are thin layers of color that can be used to cover a whole or specific area of your watercolor paper.

A wash can be flat, graded or variegated. With a flat wash, you seamlessly cover a whole area in paint. With a graded wash, you incorporate a gradual change of the intensity of a color to create the wash. A variegated wash is a wash of two or more colors that blend when applied next to each other.

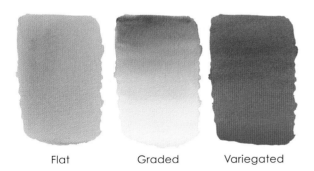

| Flat | Graded | Variegated |

Keep in mind that the larger the area you want to cover in paint, the bigger your brush should be. If you ever run into an issue with the paint being already dry once you reach the bottom side of your paper, you might want to use a bigger brush to distribute the paint.

You can create these washes either wet-on-dry or wet-on-wet.

The difference is that when you apply wet paint to wet paper (wet-on-wet), you have less control over where the paint goes. The colors will also look slightly lighter as they get diluted with additional water on the paper. But this method can give you more time to distribute the paint before it starts drying! I find it's also a lot easier to spread the paint more evenly.

If you apply wet paint to dry paper (wet-on-dry), it allows you to have more control over where the paint goes when you create flat washes. This is because, in watercolors, the paint only goes where it's wet. This way, you can also create crisp details, lines and edges without the color moving to areas to which you don't want it to go.

Try It Yourself!

Let's start with creating a flat wash!

Load your brush with wet paint. Remember to remove excess moisture from your brush by gliding it over the edge of your mixing palette. Then distribute the paint by moving your brush from left to right, back and forth, as you work your way downward. If you see any darker areas where the paint pools together, soak them up with a clean, damp brush. This way you make sure that the paint can dry evenly.

To create the graded wash, you can test out the wet-on-dry and the wet-on-wet approach to see the difference!

To create a graded wash wet-on-dry, apply the paint the same way as with the flat wash, but instead of covering a big area with paint completely, you want to create just a small area with paint. From there, you want to create a gradual transition from dark to light. For this step, rinse your brush after you apply the paint and glide the brush over the edge of your container to remove excess water. Then start blending out the paint right where you left off, moving your brush from left to right, back and forth, as you work your way downward. You basically want to use the paint along the edge and dilute it slightly as you move your brush. Then rinse

your brush again and remove excess moisture by gliding it over the edge of your water container. From there, use the remaining paint on the paper and blend it out even more. Since the paint gets lighter and lighter as you move your way downward, the water on the brush will help you lighten the colors even more.

Repeat the same technique wet-on-wet!

First, apply a little bit of water on top of your watercolor paper where you want to create the graded wash, and let it absorb the moisture just a little bit. Next, load your brush with paint and start distributing the paint the same way you did earlier. The layer of water below will automatically help you to lighten the color. If you notice that the color doesn't get lighter, it means your brush is holding too much paint. To help you blend out the paint on the paper, you want to stop and rinse off your brush, remove excess moisture from it and then continue blending out the paint. Repeat this step until you reach the lightest value of your color.

To create the variegated wash, you can also use the wet-on-dry and the wet-on-wet techniques.

Let's practice the wet-on-dry technique first! Choose two colors of your choice and apply the first color to the paper the same way as you did with the flat wash. Rinse your brush, load it up with the second color and remove any excess moisture. From there, create another flat wash below the first color while leaving out a small gap in between. This is the area where you'll be blending both colors together. Next, move your brush from left to right as you move toward the first color to blend both together. Once you've slightly mixed both together, continue to move your brush from left to right, but this time, move your way slightly downward. If there are any harsh transitions, simply rinse your brush, remove excess moisture and lightly blend out the areas with the damp brush.

You can also use the graded wash technique and combine two colors together as well! In this case, you want to make the colors blend right where their lightest values meet.

This is not only fun blending, but is also a color mixing exercise! Don't worry about making the washes perfectly flat or blended out. Sometimes having those imperfections can make the painting look more alive!

Note: The key to any successful wash of paint is even wetness. If you let the paint dry while there are small puddles of water or paint in different areas, you're dealing with different drying stages. This means that the areas of paper that are covered in more water will take longer to dry, while others will dry quickly. The puddle of water will also cause the unwanted backruns that I mentioned earlier, so if you want to avoid any blooms, don't forget to remove any excess water with a damp brush or a tissue. You're in control!

If you still accidentally get areas with blooms, you can fix that, too! You can either reactivate the whole area with water and blend out the paint again, or add another layer of paint on top to cover it up!

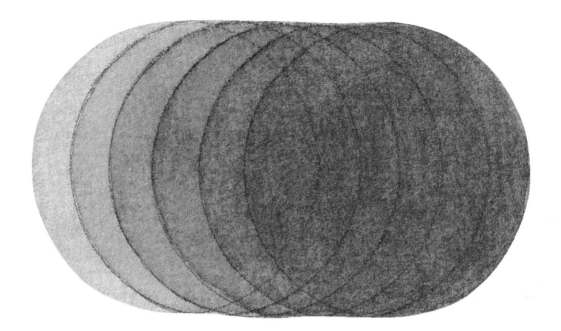

Layering

You can apply different washes of paint not only to dry or wet paper, but you can also layer them when they're completely dry. By layering your paint, you can use the transparent nature of watercolors to adjust your painting in different ways!

You can overlap a wash of paint using only one color to darken it, or you can use two different colors and create a third color. This is also known as the glazing technique. The layering technique allows you to create depth, distance, a different atmosphere and additional details on top of your painting.

As you can see in the example above, I layered the same color with the same value multiple times once the layer below was fully dry. This way you can adjust the intensity of the color, in case your first layer of paint turned out to be too light!

That's why you always want to start with a light wash of color and build up your painting one layer at a time. If you start with dark colors, it won't be possible for you to overlap them with a lighter color to adjust your artwork.

Let's Try It with One Color!

Start by outlining a wide rectangle or multiple circles as in the example. Next, prepare a light value of your color in your mixing palette using less pigment than water. Load your brush with paint and remove excess moisture from your brush by lightly gliding it over your mixing palette.

Now you want to apply the first layer onto the paper and let it dry completely. Remember, you can always use a hair dryer to speed up the drying process. Just make sure you're careful with it so you don't accidentally blow away the wet paint! Once everything is dry, repeat the steps. Load your brush with the same paint (without rinsing your brush) and apply another layer on top while leaving out some space to see the lightest color.

Make sure you gently go over the paper using minimal strokes so you don't accidentally reactivate the layer below.

Let the paint dry completely again and repeat these steps until you have reached the desired darkness!

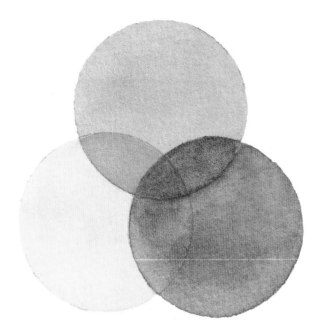

Softening and Blending

Softening an edge, sometimes also referred to as "fading out," is a great way to achieve different effects in your painting. When you paint wet-on-dry, you have crisp and well-defined edges, also called "hard edges." If you paint wet-on-wet, the object or the paint that you apply onto the wet paper will have a soft edge because of its fuzzy nature. Both ways can be used to your advantage. With this technique, you basically want to make the paint move to another area on your paper by placing the right amount of water next to the wet paint.

To fade out the color, you want to apply water to the very edge of the paint with a brush that is drier than the paint itself.

> **Note:** Make sure you don't go into the color too far, otherwise the damp brush will act like a sponge and soak up the paint instead of spreading it out.

Now Let's Try Layering Multiple Colors!

Outline three squares or circles overlapping each other as in the example. Then load your brush with a light value of blue-colored paint and remove excess moisture by gliding the brush over the edge of your mixing palette.

After that, cover one of the circles with paint and let the paint dry completely. To speed up the drying process, you can also use a hair dryer.

Now you want to repeat the step and apply red-colored paint to the second circle in the same way, but before you apply another layer on top, make sure the layer below is completely dry. You also don't want to heavily scrub with your brush, but quickly and gently apply the paint. This way you avoid activating the paint underneath. Let the paint dry again and now repeat the same steps with yellow-colored paint.

Isn't it fascinating how you can create another color simply by overlapping two colors?

Let's Try It Out!

Prepare a concentrated mixture of any color of your choice and load your brush with paint. Next, paint a line on top of your watercolor paper using the wet-on-dry technique. Now rinse your brush to make it clean, and remove some of the excess water by gliding the brush over the edge of your water container.

From there, apply the water right at the very edge of the paint.

wet-on-dry wet-on-wet wet-on-dry + softening the edge

If you notice that the water of your brush spreads into the paint, it means that you probably still have too much water on your brush! In this case, rinse your brush and remove even more excess water by gliding the brush over the edge of your water container and a little bit on a tissue. From there, you can soak up the moisture on the paper and blend it out.

The blending technique is another excellent way to either soften hard edges of your shapes or to mix colors right on the paper using the wet-on-wet technique. Instead of mixing your colors in your palette, you can blend them by layering one color over another.

Let's Try It Out!

In this example, I used Quinacridone Rose, Cerulean Blue and Lemon Yellow. But you can use any color of your choice to play around with this technique!

Start by preparing your paint inside your mixing palette. You want to create paint of a creamy consistency to make sure the paint doesn't spread out too much and looks vibrant.

Remember to pay attention to the amount of water and paint both on your paper and on your brush to avoid unwanted patchy results. If you apply paint that is too watery, it will spread out, push away the pigments and create unwanted backruns.

Next, load your brush with water and distribute it on your paper to create a circle or a square. This is the area in which you'll mix your colors.

From there, load your brush with blue-colored paint of creamy consistency and apply it to one of the edges. Rinse your brush, load it up with red-colored paint and remove any excess moisture by gliding it over the edge of your mixing palette. Now you want to apply it to another area next to the previous color and blend both colors together in between.

Once you've applied the paint and mixed both colors together, repeat the steps with the yellow-colored paint!

Lifting

The great thing about watercolors is that if you want to remove them from your painting, you can do that by simply lifting them using a damp or dry brush or a paper towel. This method reveals the white of the paper again. You can do this while the paint is still wet or when it's already dry. When it's still wet, simply press down with your damp brush or paper towel on any area you want to lighten again.

Note: If the paint has already dried, you want to reactivate the pigments again. Use a wet brush and lightly rub over the area you want to erase. From there, use your paper towel to lift off the pigments. If your brush is too soft, it might be more difficult. In this case, you want to use a brush with bristles that are more stiff and hard.

Dry Brush

The dry brush technique is a great way to add additional texture and effects to your painting, such as light reflections in the water, grass, tree bark and so much more. The difference between this and the regular wet-on-dry painting process is simply the way you hold your brush and the speed of how fast you move it. Instead of slowly painting with the tip of your brush, you use the belly and move it with its side quickly over the paper. This technique works best on cold-pressed or rough paper, as both have texture that enhances the effect.

Let's Try It Out!

For this technique to work, you want to load your wet brush with paint and then dab off a little bit of excess water using a tissue or paper towel. Then hold your brush slightly slanted and quickly brush it over your paper. You can also test out different angles and brushes to see what you can create. Because you move your brush quickly, the paint doesn't have enough time to sink into the texture of your paper. Instead, you create broken brush strokes. You've created light reflections on top of the water! Now you can paint a small boat along the horizon, or a simple but beautiful ocean or lake scene!

Let's Try It Out!

Load your brush with paint of a slightly watery but still creamy consistency and apply it to the paper by creating a flat wash in a round or rectangular shape. Next, rinse your brush in clean water, remove excess water by gliding the bristles over the edge of your water container and lightly dab them onto a tissue or paper towel a few times. Now you can use your damp brush to soak up the wet paint. You can either create lines or curves to create light reflections. This way, instead of applying the paint by moving your brush in a straight or curvy line, you absorb the paint from the paper to reveal the white again.

Note: Keep in mind that the amount of paint you can remove depends on the pigments and the paper you're using. If you use dye-based or very staining watercolors, it might be difficult to remove everything. The same goes for your paper. Here, the sizing of the paper that I mentioned in the section about watercolor paper (page 9) comes into play.

Round Brush

Flat Brush

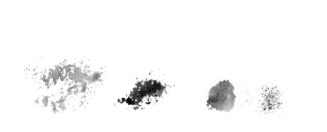

Painting with a Sponge

After using the dry brush technique to add texture and effects to your painting, you can also use a sponge!

In these examples, I used a synthetic sponge and played around with different greens, amounts of water and paint to create the trees. Remember, in watercolor painting you want to layer your paint! So start with a lighter color and then build up the object using wet-on-wet or wet-on-dry! If you don't want your hands to get dirty, you can wear gloves as well!

Let's Try It Out and Paint a Tree!

Start by preparing your paint first. To create the tree, you're going to need a yellow ochre and a green-colored paint of creamy consistency.

For this technique to work, dip the edge of your sponge into the water and squeeze it out so the sponge is not too wet.

Then dip the sponge into the yellow-colored paint. Before you apply the paint to your painting, test it out on a separate piece of paper. Then lightly touch the paper with your sponge. If you press the sponge down too much and it is holding a lot of water, you'll lose the texture. If it's too dry, the texture will look like small dots. You can experiment with both!

You'll also notice that if you use the side or just the tip of the sponge, you'll create different textures. Play around with it! Turn the sponge in your hand so the pattern is not too repetitive, and experiment with different amounts of water and paint until you get familiar with this technique.

Once you've gotten more familiar, it's time to paint the tree!

Again, dip the edge of your sponge into the water and squeeze it out so the sponge is not too wet.

Then dip the sponge into the yellow-colored paint and press the sponge down onto your paper to create the crown of the tree. After that, repeat the step to create another row of leaves below. These are going to be the leaves that get more sunlight than the rest of the tree.

From there, you want to dip the edge of your sponge into the green-colored paint and dab it on top of the yellow ochre–colored paint, while leaving a little bit of the yellow paint showing to keep the highlights.

Again, play around with how you hold your sponge and press it down!

Once you've created the leaves, load your clean brush with brown-colored paint and paint the tree trunk. For this step you simply want to create a straight line that gets wider at the bottom. From there, you can even use a darker brown color and paint additional thin lines in between the leaves to create branches that are visible in a few areas. And you're done!

Tips Before You Begin Painting

One of the things that can make us all feel overwhelmed is the fear of the blank page. There is so much white space staring at us with all the possibilities that it can be scary, right?

What helps me is to paint on a small scale. I usually either divide my paper into small sections, or I cut a loose sheet of paper into smaller pieces. This gives me not only more courage to fill up all the space and to do it faster, but it also allows me to try out different variants of the same painting idea. Once I work out my idea, I can decide whether I want to paint it on a bigger scale or not.

In this book, you'll find a lot of projects that you can use to create a variety of different paintings using the same techniques. Feel free to prepare multiple painting areas on your watercolor paper! This way you can play around with different ideas and colors simultaneously.

If starting a new creative hobby is not a problem for you, but sticking to it is, giving yourself a sense of purpose might help with that! Keep reminding yourself why you want to learn how to paint with watercolors in the first place. Do you want to use it as a time to unwind, relax and to express yourself? Or maybe you enjoy the fact that you're creating something for your friends or family. This way you not only add beauty to the world with your own hands, but you create meaningful gifts that others can admire as well!

All of my paintings in this book were made on a small scale as well. I used loose sheets of 140 lbs/300 gsm cold-pressed watercolor paper made out of 100 percent cotton. I switched between different brands such as Arches, Saunders Waterford, and Hahnemühle. After spending so much money on watercolor pads that I quickly ran out of, I realized investing in good-quality watercolor supplies doesn't have to be expensive! You just need to be smart about it! That's why I switched entirely to loose sheets of paper that are way more affordable in the long run.

I also used only two brushes: one medium round brush for painting and adding details using its fine tip, and one flat brush to distribute water or one big wash of paint as mentioned on page 11. If it's easier for you to use small brushes for details, go with what works best for you!

With each painting project, you'll also find the colors I used to create a specific painting. Don't stress about using precisely the same color with the same name. If you don't have the same colors, don't worry! By following what you've learned about "the art of color mixing" at the beginning of this book, you can easily match your colors with mine. Focus on training your eye to see the difference between colors and how to mix them. This way you don't have to stress about what exact color other artists are using, but you can choose your colors accordingly.

Remember, watercolor painting is not about creating a perfect painting. It's also not about trying to copy a reference precisely as you see it. Let what you see inspire your own artwork by giving it your own twist and personality! Focus on the present moment, enjoying the painting process and, most importantly, enjoying yourself!

You never fail; you only learn. Have confidence!

Don't be afraid of wasting your art supplies. If something doesn't turn out the way you hoped, don't worry! Every artwork is a valuable experience and nothing is wasted. But it's a waste to do nothing at all!

You've got this!

Painting Projects

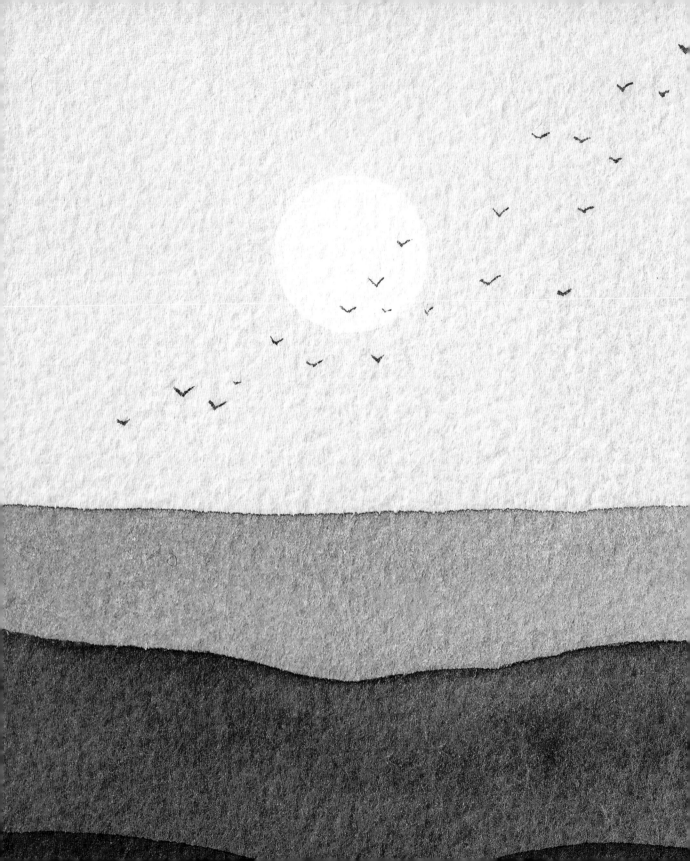

Under the Sea

Painting the ocean is not only super fun and therapeutic, but it's also a great way to practice your watercolor painting skills without getting lost in too many different colors! And water is one of the key elements of a landscape painting.

The following painting projects will allow you to get familiar with different watercolor techniques. You'll be able to practice not only how to adjust your paint-to-water ratio and color mixing skills, but also how to layer and blend your watercolors together using the wet-on-dry and the wet-on-wet techniques. By following a simple rule for composition, you'll also learn how to achieve harmony in your painting while creating distance and depth using basic watercolor techniques!

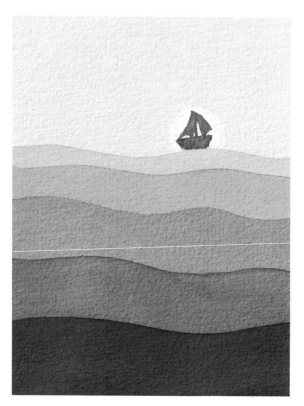

Sailing Away

The transparent nature of watercolors allows you to build up your painting one layer at a time and to create a sense of space. You don't even need many different colors for this! With just one color, you can create a simple but beautiful painting! This is what you're going to explore with this painting project.

In this first exercise you're going to practice the paint-to-water ratio to adjust the intensity of your colors, as well as layering multiple flat washes to create depth.

Materials you'll need

Masking tape

Watercolor paper

Size 8 round brush

20mm flat brush

Tissues or paper towels

Small coin

Color

Cerulean Blue

Step 1

Using masking tape, outline a rectangle or square on your watercolor paper and tape it to a board or desk. This will be the working area of your painting.

Note: Watercolor painting is all about timing! As soon as you apply paint to the paper, the paper starts to absorb the color and dry, so the key is to make sure you can work quickly without running out of paint during your painting process by preparing more paint than you expect to use. This way, you can cover everything in one go.

And this is what you want to do now!

Start by creating a big puddle of water in your mixing palette. It needs to be big enough so you can cover the whole paper multiple times.

Next, using your round brush, add a little bit of Cerulean Blue (or any color of your choice) into the puddle to dilute the paint. The more water you use compared to pigment, the lighter and less saturated the color becomes. You'll notice that the mixture is also watery.

Swatch the color on a separate piece of paper to make sure it's not too dark and not too light. Remember, watercolor paint looks lighter when dry!

Then load your flat brush with the paint you just prepared and start applying it all over the paper. Move your brush from left to right, up and down and back and forth to distribute the paint as evenly as possible. If you see any darker puddles of excess water and paint, soak them up with a damp brush or tissues. Distribute the rest to make everything look evenly applied to avoid any patchy results when everything is dry.

This is going to be the first layer of paint and the background for the rest of the painting.

While the paint is still wet, it's time to add the shining sun!

Step 2

For this step, you're going to use the lifting technique (page 35). This means that you'll reveal the white paper again by soaking up the wet paint using tissues.

Wrap your tissue or paper towel around a small coin. Make sure to tuck the excess paper behind the coin by twisting it together to create a flat, round surface.

Press the coin down onto the wet paper following the rule of thirds. This means you should divide your painting area into thirds vertically and horizontally. The intersections of these lines are great areas for anything you want the viewer to focus on, in this case using one of the upper intersections to position the sun.

While the coin is pressed down, the paper towel will soak up the wet paint. Next, lift the coin off to reveal the white area below!

Note: If you use dye-based watercolors, you might have trouble lifting off the paint, as dye-based watercolors are staining.

Let everything dry completely. Remember, the more watery your color mixture is, the longer it will take for the paint to dry. To speed up the drying process, you can use a hair dryer!

Step 3

Now it's time to paint the waves!

This time you want to make the color value slightly darker. Again, the more pigment you use compared to water, the darker the color becomes!

Swatch the color on a separate piece of paper to make sure the color is slightly darker, then load your flat brush with paint.

To make the painting look harmonious, continue to keep the rule of thirds in mind. In this painting, you want to use the horizontal lines to create the horizon. In this case, the horizon will be right around the first horizontal line from the top.

By holding your brush parallel to this line, you can use the edge of the bristles for easier paint application. Begin

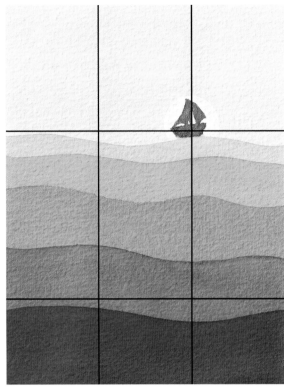

painting a line across the paper. Start right below the upper third of the paper and move your brush in a wavy motion. It's okay to paint slightly over or below the sun!

Once you've reached the other side of the paper, fill the lower area with paint in the same way you did to create the background. This time, though, you want to make sure you don't heavily scrub over the paper or you'll reactivate the paint underneath (see Layering, page 33).

Again, make sure to remove any excess paint using a damp brush or a tissue.

Then let everything dry completely! Again, you can use a hair dryer to speed up the drying process.

Step 4

Once everything is dry, you want to repeat Step 3 with darker paints. The area of water that is closer to the sun is lighter, and everything gets darker and darker as the perspective moves closer and closer to the viewer.

This time, you also want to increase the distance between each wave. Using this method will easily create distance!

Every time you add another layer of paint to create the waves, make sure to make the space in between those lines wider and wider as they move closer to the viewer.

If you run out of paint after applying one of the layers, don't worry! Simply create another puddle of water and prepare the needed color value. Don't forget to swatch it first!

Notice that the more pigment you add to the water to create a darker value, the creamier the consistency becomes.

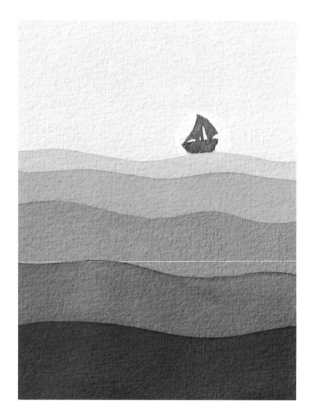

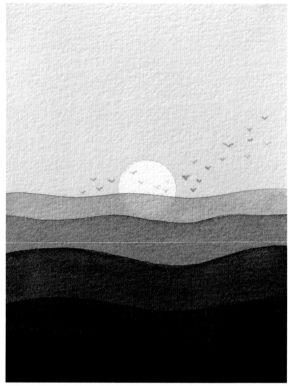

Step 5

No matter how many waves you want to create for your painting, the color value that you use for the very last wave in the foreground should be relatively dark.

Now, if you want, you can also use the same color value and add a silhouette of a small boat right in front of the sun using your round brush.

As the sun is directly behind this boat, you can only see its dark silhouette.

Now let everything dry, and you're done!

There are so many different ways you can use this technique to create ocean scenery! For example, you can use different colors to change the mood and atmosphere. You can also play around with where you place the sun or the horizon, and what you add (or don't add) to the painting to make everything come together!

Alternative 1

Here I used only Payne's Gray and its different values. This way, the whole atmosphere looks rather gloomy, cold and dark. Instead of the ship, I added small, simple "v" shapes to create birds flying above the ocean.

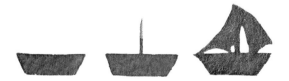

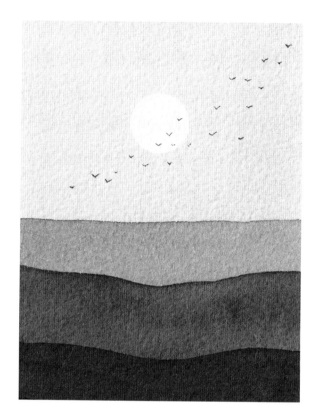

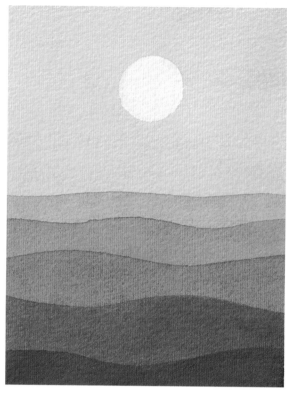

Alternative 2

By using purple, you can make the whole scene look mysterious. Here I mixed Ultramarine and Quinacridone Rose, then added more and more pigment of both colors to make the value darker and darker.

Alternative 3

If you want to make the atmosphere more warm and friendly, you can also use different orange, red and brown colors. Here, for example, I mixed a peachy and less vibrant orange using Cadmium Yellow and Carmine Red. But you can also use Quinacridone Rose or Carmine Red and Cadmium Yellow or Azo Yellow.

From there, I mixed in more and more pigments but used slightly more of the red color to make the value darker, as yellow colors already have light values from the start.

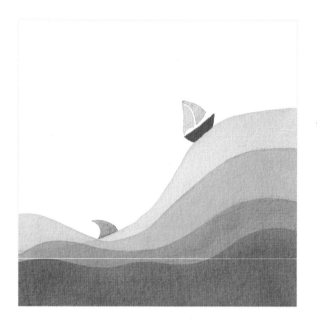

Catch Me If You Can

●○○ BEGINNER

With this painting project, you're going to continue practicing the paint-to-water ratio and layering washes to create depth, as well as adding details. This time, let's switch things up and add more color and movement to the painting to tell a story!

Similar to the first ocean painting, you're going to overlap one single color in multiple layers of value from light to dark to create depth.

Materials you'll need

Masking tape

Watercolor paper

20mm flat brush

Tissues or paper towels

Size 8 round brush

Colors

 Cerulean Blue

 Payne's Gray

 Cadmium Yellow

 Carmine Red

Step 1

Using masking tape, outline a square on your watercolor paper to prepare your painting area and tape the paper to a board or desk.

Next, create a big puddle of watery paint using Cerulean Blue in your mixing palette. Swatch the color on a separate piece of paper to make sure it's not too light. Remember, watercolor paint looks lighter when dry!

Now you want to use the rule of thirds again— divide your painting area into thirds vertically and horizontally (see figure 1 on page 50). This way, you'll not only make the painting look harmonious, but also you'll be able to draw the viewer's attention to the details you're going to add later!

Load your flat brush with the paint and start applying it by creating a curve as shown in the reference picture, following the rule of thirds. Once you've painted the curved line, fill the rest of the space below it with paint using your flat brush. Before you let the layer dry, make sure to remove excess paint and water from your paper using a damp brush or a tissue. This way you avoid any patchy results when everything is dry.

Step 2

Once the first layer of paint has dried, it's time to create the second wave! This time you want to add a little bit more Cerulean Blue to your puddle to make the color value darker.

To create the second wave, you want to start creating another wavy line slightly above the first wave. Continue the line going downward and upward again, but staying below the first wave. Then fill the rest of the area below. As you can see, the white paper kept the color that you created, and the dry layer of paint made the value darker, simply by overlapping both! This is the wonderful transparent nature of watercolors!

To make sure you don't accidentally reactivate the paint below, remember to gently move your brush over the paper. If you scrub the paper too much, you will reactivate the pigments.

Let everything dry completely again. Again, you can use a hair dryer to speed up the drying process.

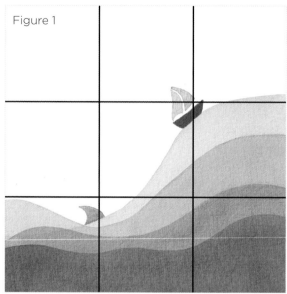

Figure 1

Step 3

Now repeat the previous steps to create more waves. The more pigment you add to your puddle, the darker the color will become.

Pay close attention to the consistency of your color mixture as well! The more pigment and less water there is, the more creamy and buttery the paint will become! The more water and the less pigment, the more watery the consistency of the paint will be!

Step 4

Once the waves are dry, it's time to add the details!

Following the rule of thirds, add the shark fin to the lower-left intersection using a light value of Payne's Gray and the round brush. In this case, place it right at the lowest area of the first wave. Then paint a small boat on top of the upper-right intersection using Cadmium Yellow and Carmine Red.

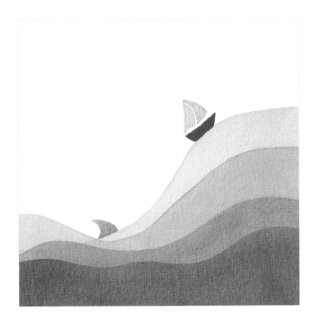

If you take advantage of the rule of thirds and where you place your objects, you can convey a whole story!

The viewer will discover the bright red boat that barely can stay on the wave. At the same time, the viewer's eye will move to the lower-left side of the painting, where the viewer will discover that the boat is actually trying to escape the shark that is following it.

Will the boat escape the shark?

Alternatives

There are many ways you can recreate this painting project. Play around with where you place the waves, where they overlap and where they don't. And instead of painting a shark and a boat, you can paint different things—for example, the tail of a whale!

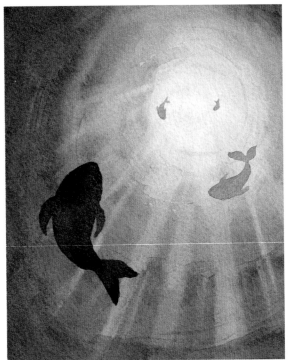

Deep in the Ocean

●● ○ INTERMEDIATE

When you paint wet-on-dry, you have crisp and well-defined edges called hard edges. If you paint an object wet-on-wet, the edges will be soft and fuzzy. Both ways can be used to your advantage!

As you continue practicing your paint-to-water ratio skills using the wet-on-dry technique, this painting project will slowly introduce water as a blending tool. With this blending technique, also known as softening or pulling, you make the paint move to another area on your paper using water. The key is to use the right amount of water and place your brush correctly. This painting will also help you learn more about how you can create harmony in your painting and how to create the illusion of distance and depth.

Materials you'll need

Masking tape

Watercolor paper

20mm flat brush

Size 8 round brush

Tissues or paper towels

Colors

 Cerulean Blue

 Lemon Yellow

Step 1

Using masking tape, outline a rectangle on your watercolor paper. This will be the working area of your painting. Then tape the paper to your desk or board. Prepare a big puddle of watery paint in your mixing palette using Cerulean Blue. It needs to be big enough so that you can cover at least the whole paper in paint.

To create depth in our under-the-ocean painting, use the rule of thirds again. Load your flat brush with the paint you prepared and start distributing it all over the paper, leaving a little bit of white space right at the upper-right intersection.

Once you've applied the paint, use a clean, damp round brush to soften the inner edges of the space you kept free from paint (page 34). Make sure you don't go into the paint too far or the damp brush will act like a sponge and soak up the paint instead of spreading it out.

If you get paint on your brush, don't worry! Use it to your advantage by adding a few small lines in a circular motion to add additional shadows in the ocean. While the paint is still wet, move to the next step!

Step 2

While the paint is still wet, you want to use the lifting technique (page 35) to create rays of sunlight using either a dry brush or a tissue. For this step, follow the lighter area of your painting as a guide and create a few diagonal lines below it by lifting off the paint.

If you notice your paint has already dried and it's rather difficult to lift from the paper, don't worry! Simply use a clean, wet brush to reactivate the paint following the shape you want to lift off. Then use a tissue to soak up the reactivated color. (Remember, if you use very staining colors, such as dye-based liquid watercolors, this technique will be tricky to use.)

Then let everything dry completely!

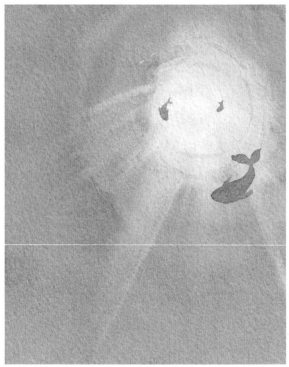

Step 3

This time, you want to create a darker value of paint as we go deeper and deeper into the ocean. If you ran out of paint earlier, don't worry! Create another big puddle of water and add a little Cerulean Blue and also Lemon Yellow to dilute them to create a greenish-blue. Swatch the color on a separate piece of paper to make sure it's not too dark and not too light.

Load your flat brush with the paint you prepared and distribute it around the lighter area. Once you've covered everything in paint, use your damp brush to soften the edges. As you can see here, my round brush picked up a little bit of paint, and I used this to create additional fine lines inside the lighter area to add more shadows inside the water.

While the paint is still wet, create new sunrays using your dry brush or a tissue. This time, you want to make sure that the shape of the sunray is slightly wider at the bottom and narrower around the top to create distance. Then let everything dry completely again.

Step 4

Once the paint is dry, it's time to introduce some additional details to your painting. In this case, dolphins!

As things move into the distance, they seem smaller, less detailed and the color becomes lighter. To create a distinct contrast, you want to use the same color value that you used to create the previous wash to paint the dolphins.

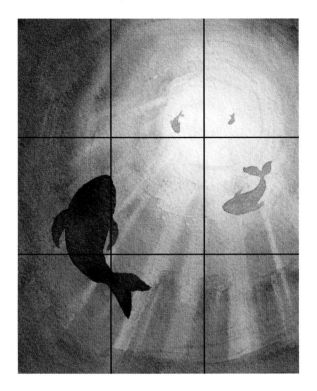

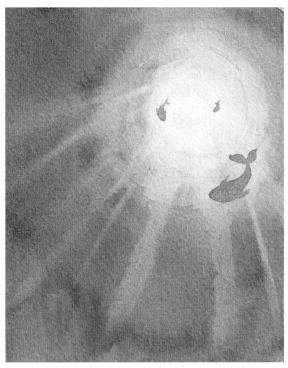

Load your round brush with paint and remove excess moisture by gliding it over the edge of your mixing palette. This way you make sure that instead of adding a big blob of water onto your paper, you have more control over the details.

Again, use the rule of thirds and paint three small dolphins around the upper-right intersection, where the light source is. Place one dolphin facing to the left and the other dolphin to the right, as they surround the sunlight. Then paint a third and bigger dolphin that is closer to the viewer, right below those two.

Think of them as small curved drops, with small round dots next to the body and a v-shaped tale. If you want, you can also lightly sketch them out on the paper first before using paint!

Step 5

As the dolphins dry, add a little bit more Cerulean Blue and Lemon Yellow to your previous color mixture. The consistency of the paint should slowly become creamier and creamier as the ratio of paint increases compared to the water.

Load your flat brush with paint again and repeat the previous steps. This time increase the distance to repeat Step 3 that you softened earlier as you apply the paint.

While the paint is still wet, use a tissue or a clean, dry brush to lift off the paint right on top of the previous sunrays as well as right next to them.

Then let everything dry completely again.

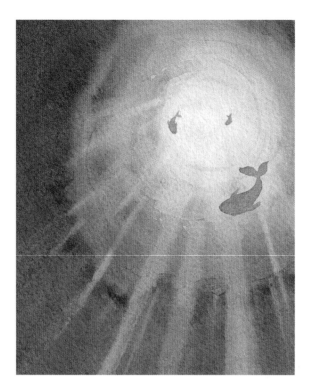

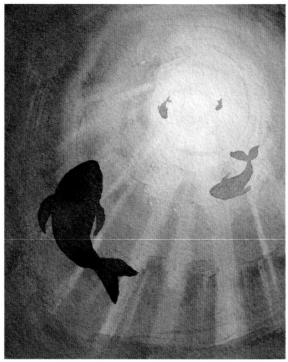

Step 6

For the last layer, you want to use an even darker value of the same color mixture. But to change things up, you're going to add Lemon Yellow right into the wet paint on the paper.

If you ran out of paint, don't worry. Simply create a small puddle of water and add Cerulean Blue and Lemon Yellow to dilute them. Make sure the consistency of your color mixture is creamy. If it's too watery, add more pigment. If it's too dry, add more water!

Apply the paint the same way as in the previous step, but this time, add a little bit more Lemon Yellow straight into the wet paint. This way, some greenish-blue areas turn into bluish-green.

Once you've applied the paint, use a tissue or dry brush to reveal some of the sunrays again.

Then let everything dry.

Step 7

Last but not least, once the previous layer of paint has dried, it's time to add the last dolphin. This time you want to place the dolphin to the left side of the painting, using an even darker value of the same color.

Use even more Cerulean Blue and just a little bit of water to make the color value as dark as possible. Since this dolphin is closer to the viewer, you want to increase its size and sharpness, as well as make it more saturated in color. This way, you can clearly see the contrast between the small and light silhouettes of the dolphins in the distance and the big and dark dolphin in the foreground.

Let everything dry again, and you're done!

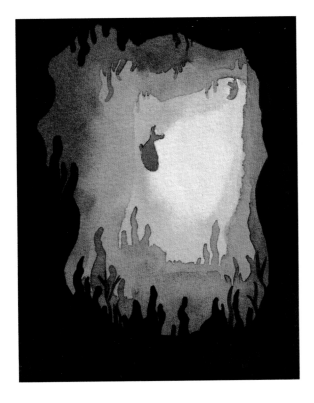

Ocean Cave

● ● ○ INTERMEDIATE

With this painting, we'll go deeper into the water to discover the hidden secrets of the sea!

Another great way to create the illusion of depth and distance is by overlapping shapes. You can create a dark foreground while keeping the shapes soft and light in the distance. This way you give the viewer the feeling that he is about to discover a secret place! In this painting project, you're going to use the softening technique that you've used to create the previous painting, but just in a few areas. This way, you'll emphasize the play between the light and water, and also add an element of motion. We're not going for realism here—just have fun and enjoy the painting process!

Materials you'll need

Masking tape

Watercolor paper

HB pencil

Masking fluid

Small brush for masking fluid

20mm flat brush

Size 8 round brush

Tissues or paper towels

Colors

Cerulean Blue

Lemon Yellow

Carmine Red

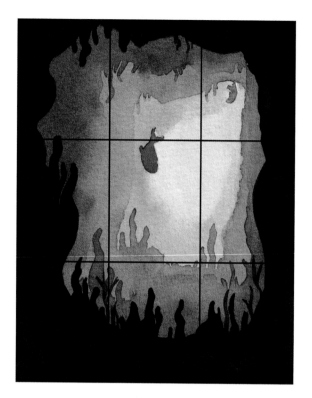

Step 1

Using masking tape, outline a rectangle or square on your watercolor paper. This will be the working area of your painting again. Then tape your paper to your desk or board.

Using the same silhouette shape as you created in the previous painting, lightly sketch out two small fish outlines around the upper-right intersection following the rule of thirds again. The fish closer to the viewer should be slightly bigger than the fish in the background in order to convey the distance in the cave.

Cover these outlines using masking fluid on your brush. By using masking fluid, you'll protect the white of the paper as you paint everything around it.

While the masking fluid is drying, prepare a watery mixture of a light greenish-blue color using Cerulean Blue and just a little bit of Lemon Yellow. Remember to prepare more paint than you need!

Once the masking fluid is dry, cover the whole area with a flat wash of the paint mixture using a flat brush. The fish silhouettes that you covered in masking fluid will now be resistant to the paint, so you can focus on covering the paper in an even wash.

Before letting everything dry, make sure to remove any excess water and paint using a damp brush, so everything can dry evenly.

Step 2

To create depth in the cave, you want to mix an even darker value of the previous color. If you ran out of paint from the first wash, simply create another puddle of water, and this time add a little bit more Cerulean Blue and Lemon Yellow to make the color darker.

Next, apply another wash of paint using a flat brush, but this time paint around the fish silhouettes. They are going to be in the area in the cave that gets more light.

Don't worry about making the wash super-even. If something looks patchy, use this to your advantage! "Imperfections" in your art can make it look even more interesting and add so much life to it.

Then use a clean, damp brush to blend out the hard edges to create a soft transition to the layer of paint below (page 33).

Then let everything dry again. Remember, you can always use a hair dryer to speed up the drying process!

Step 3

Once the paint has dried, we can now create another layer that is even closer to the viewer. This means you want to use an even darker value, as this area is farther away from the light source. You also want to make the edges of the cave more in focus, so it doesn't look as blurry as the area in the background.

This time add a few simple silhouettes of seagrass as well to switch things up.

Prepare a darker mixture of Cerulean Blue and Lemon Yellow by using more pigment than water. Then load your flat brush with paint and distribute it the same way as for the previous wash, but this time, as you leave out space around the light source, paint simple wavy silhouettes for the seagrass. You can change up their height and place them so that they hang down the cave. It should look like a small window with seagrass around it.

Now, instead of blending out every hard edge, do that with just a few edges here and there.

Then let everything dry again.

Step 4

Once the previous layer has dried, it's time to create another layer of paint as we add more depth to the cave. This time, the walls of the cave are even closer to the viewer and look a lot darker.

Use an even darker value of the previous color by using even less water compared to the paint. You'll notice that the darker the value gets, the creamier the consistency becomes. If you have a hard time distributing the paint, add a little bit more water to your mixture.

To add variety to the wash, you can also add a little bit of Lemon Yellow straight into the wet paint on the paper in the same way as in the previous painting.

Then repeat Step 3.

Step 5

Once the paint has dried, carefully remove the masking fluid by peeling or rubbing it off. If the pencil lines are too visible, carefully erase them.

To be able to draw attention to the fish, it's best to use a color that has the opposite characteristics of the cool blues and greens we used to create the cave. In this case, we can use a warm color like a vibrant red and paint it with crisp outlines. Since the masking fluid protected the white of the paper, it will shine through the paint, making the color of the fish clean and vibrant.

Now, use your round brush and paint the fish in the foreground using Carmine Red or any other warm color such as yellow or orange.

To keep the focus on the red fish, I used a lighter value of the greenish-blue color that I used to create the cave for the fish in the background.

While the paint is drying, add the final layer of color to create the walls of the cave. These are now super-close to the viewer. This time, you want to use a lot more pigment than water to create the darkest value possible using Cerulean Blue and Lemon Yellow.

Once you've created that layer of paint and added a few silhouettes of seagrass, keep the edges sharp and let everything dry!

Ocean Waves View

●●○ INTERMEDIATE

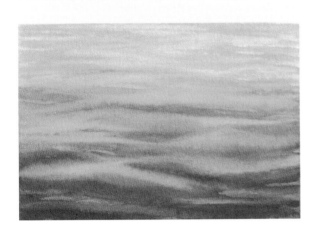

Now that you're more familiar with the wet-on-dry technique, you know that when you apply wet paint onto dry paper, you have full control over where the paint goes. The edges of the subject that you paint are crisp as well. But you also know you need to wait for that layer of paint to dry before applying another on top. With the wet-on-wet technique, you don't need to wait for the paint to dry. But you do need to know how much paint and water should be on your paper and brush and work quickly!

This is what you're going to explore with this painting project! You'll also learn how to blend watercolors to create a graded wash and create movement when painting water by using the softening technique.

Materials you'll need

Masking tape

Watercolor paper

20mm flat brush

Tissues or paper towels

Size 8 round brush

Colors

 Cerulean Blue

 Lemon Yellow

Step 1

Using masking tape, outline a rectangle or a square on your watercolor paper. This will be the working area of your painting again. Then tape your paper onto your desk or board.

Prepare Cerulean Blue with a creamy consistency inside your mixing palette. To make the water slightly more turquoise later, prepare a little bit of Lemon Yellow paint with a concentrated consistency inside your mixing palette as well.

Load your flat brush with clean water and distribute it all over the paper. Make sure you soak up any excess water that might gather around the edges using a damp brush or a tissue. Remember, if your paper tends to dry quickly, allow it to absorb the moisture a little bit. Then apply another wash of clean water on top the same way.

Next, load your flat brush with blue paint and apply it right at the bottom of the paper and start blending the color by moving your brush from left to right, back and forth, as you move upward. You want to achieve a transition from a dark value at the bottom to a light value at the top to create a graded wash (page 31).

If you reach the center of the paper and notice that the color doesn't become lighter, rinse your brush and dab off some of the excess moisture using a tissue. Then use the paint on the paper where you left off to blend out the rest using your damp brush. While the paint is still wet, it's time to add the waves and ripples!

Step 2

The key is to make sure you don't add additional water to the paper. If your paint is too watery, it will simply push away the pigments on top of the paper and create unwanted blooms.

Once you've applied the graded wash to the paper, load your round brush with the same color. Make sure you use more pigment than water, so the paint is very concentrated. Then remove some of the excess moisture from your brush using a tissue or a paper towel.

Begin applying paint, starting at the bottom. Paint horizontal and slightly wavy lines that are thicker in the foreground. As you move your way upward toward the horizon, make the lines slightly thinner to suggest distance.

To make the water slightly more turquoise, dip your brush into your prepared Lemon Yellow, soak up any excess moisture using a paper towel or tissue and lightly blend it into the wet paint to a few areas.

Step 3

Once everything is completely dry, it's time to layer additional waves on top to make the ocean look three-dimensional!

For this step, we're going to use the softening technique and paint a few waves at a time. Load your round brush with the same blue color and a little bit of yellow. Then start creating large zig-zag shapes in the foreground. To do this, move your brush upward, slightly to the side and change up the direction.

Rinse your brush, dab off some of the excess water from your brush using a tissue and lightly blend out the zig-zag shapes you just created to soften the edges. Remember, you don't want to go into the wet paint too much. Instead, you want to make it move into the damp area you create for it using your brush.

From there, repeat this step with the rest of the waves. Continue applying the paint in a zig-zag shape and blending out the hard edges with clean water.

When you paint the waves, you want to decrease the space in between each line you paint as you get closer to the horizon—so the closer the perspective is to the viewer, the bigger the space between the waves. The farther away from the viewer and closer to the horizon, the smaller the space in between the waves, as this part of the ocean is far away. The same goes for the thickness of the lines. The closer to the viewer, the thicker the wavy lines. The farther away, the thinner.

Then let everything dry again!

Step 4

Remember, once the layer of paint has fully dried, you can still continue adjusting your painting if you want!

You can apply another wash of paint to even out areas or make the layers even darker. From there, you can use the lifting technique and remove some of the paint using a clean damp brush on top of where the wave is the highest. This way you get areas in the waves that get different amounts of light.

Let's Go to the Beach

Now it's time for us to go to the beach!

With these projects, you're going to continue practicing all the previous watercolor techniques using the water theme. But this time, you're going to introduce slightly more colors and details into your paintings as you learn how to create depth and distance in a few different ways! You're going to explore creative ways for using masking fluid and the graded and wet-on-wet washes to make your paintings look more interesting in a fun and simple way!

Monochromatic Beach Sunset

● ○ ○ BEGINNER

Using the wet-on-wet technique is not only great for creating loose transitions between colors, but also for adding depth to your painting. This way you can draw attention to an object that has hard edges while blurring out the rest.

In this painting project, you're going to do exactly that! To keep things simple, we're going to use a monochromatic color scheme. The key here is to make sure your paint is ready to go and that you work quickly! Make sure to read the instructions first before following along!

Materials you'll need

Masking tape

Watercolor paper

20mm flat brush

Tissues or paper towels

Small coin

Size 8 round brush

Colors

Burnt Sienna

Burnt Umber

Payne's Gray

Step 1

Using masking tape, outline a vertical frame on your watercolor paper and tape it down to your desk or board.

With this painting, you want to work quickly, as we're going to use the wet-on-wet technique.

Let's prepare the paint first!

For the first wash, you're going to need a light value of Burnt Sienna. Prepare a small puddle of water in your mixing palette and dilute the paint. The mixture shouldn't be too watery!

For the waves and the silhouettes in the background, you're going to need a concentrated mixture of Burnt Umber and Payne's Gray.

First, load your flat brush with clean water and apply it all over the paper. Go back and forth, up and down. Make sure to distribute the water everywhere and to remove any excess puddles using a damp brush or a tissue.

For the first wash, create a graded wash (page 31) starting from the top and bottom that fades out toward the center. Load your round brush with Burnt Sienna, apply the paint to the top and start blending it out toward the middle of the paper, then repeat this same process starting at the bottom.

While the paint is still wet, move on to the next step!

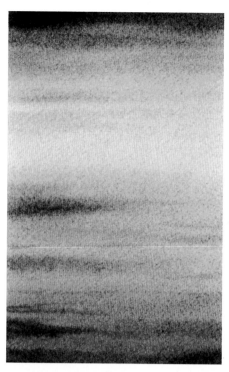

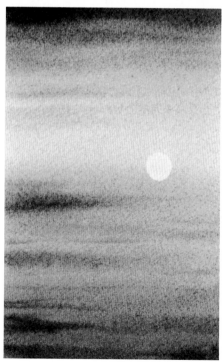

Step 2

Now it's time to build up the painting by adding a few simple shadows in the water and in the sky.

Because we don't want the next wash of paint to cause uneven results, use a very saturated mixture of paint. In this case, load your round brush with Burnt Umber and make sure to remove any excess water from your brush. You only want to add pigment to the wet layer of paint.

Create a few horizontal streaks on the lower half of the painting to create shadows in the water. Start with broad strokes using a lot of pigment while lightly moving your brush from one side to the other. And as you move your way upward, just add a few thin lines here and there while decreasing the space in between to emphasize the distance.

Repeat this step on top of the sky. Here, you only want to add a few horizontal lines that are on top and a few additional ones that are closer to the horizon.

Step 3

While the paint is still wet, wrap a tissue around a coin and tuck away the excess paper behind the coin to create a flat surface. Press the coin down onto the wet paper just above the horizon on the right side. While the coin is pressed down, the tissue will soak up the wet paint. Next, lift off the coin to reveal the white area below!

If you have difficulty lifting off your paint because the paint is too dry, simply reactivate the paint using a damp brush. Carefully scrub the brush over the circle to reactive the pigments, then use a tissue to lift off the paint.

You can also use white gouache or acrylic to cover up the area or use masking fluid right from the start instead!

Step 4

As the paper is damp by now, load your damp brush with a very saturated mixture of Burnt Sienna.

Make sure to remove any excess moisture from your brush, otherwise the water will push away the pigment on the paper.

Apply the paint across the horizon and slightly below the sun. This is going to be the blurry horizon in the background.

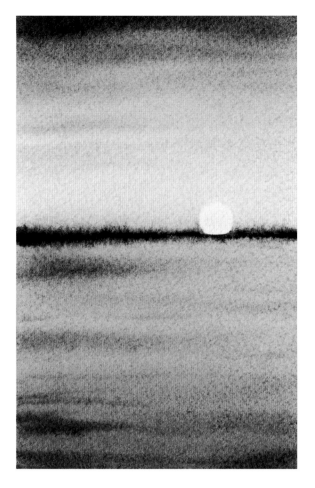

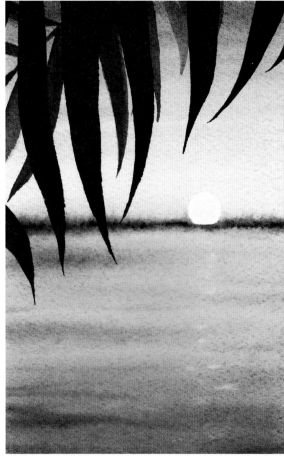

From there, apply another line across the horizon using Payne's Gray or an even darker version of Burnt Sienna or Burnt Umber. Then let everything completely dry.

Step 5

Because we painted wet-on-wet to create the sunset over the ocean, we want to add a few simple silhouettes of leaves to the foreground using the wet-on-dry technique. This way it will look like the leaves are in focus, while the background is blurred out.

For this painting, I created two rows of leaves using two different values, but you can also just paint one or even more!

To create the first rows, prepare a creamy mixture of Burnt Umber and then use your round brush to paint the leaves that are hanging down. Simply press down on your brush as you move downward and to the side, then carefully lift it off to create a fine point for each leaf.

Let the first row dry and repeat this process with the second row of leaves.

This time you can use Burnt Umber and Payne's Gray to make the color as dark as possible, as this row of leaves gets even less light.

Let everything dry and you're done!

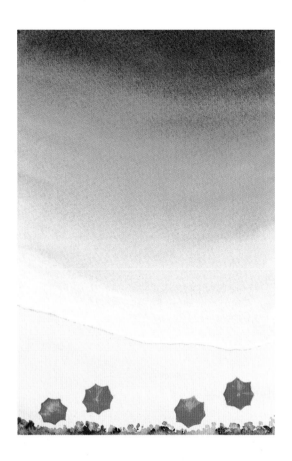

The Ocean from Above

● ● ○ INTERMEDIATE

The ocean is not only beautiful to look at, but it's also so relaxing to paint. Another fun way to paint the sea is by simply changing the perspective. The vertical format of this project will help you illustrate the size of the ocean compared to the umbrellas below, as the viewer's eye moves up and down your composition.

With this painting project, you're also going to continue practicing your water control and water-color mixing skills, also adding details.

Materials you'll need

Masking tape

Watercolor paper

HB pencil

20mm flat brush

Tissues or paper towels

Size 8 round brush

Colors

 Cerulean Blue

 Lemon Yellow

 Yellow Ochre

 Cadmium Red

Step 1

Using masking tape, outline a rectangle on your watercolor paper and tape it to your desk or board. Then use an HB pencil and lightly sketch out a wavy curve slightly above the bottom third of the paper. This is going to be the area where you'll add the ocean foam and the umbrellas below.

Next, you want to prepare the paint for the ocean. Create a small puddle of water in your mixing palette and add Cerulean Blue to dilute it. You want to achieve a very concentrated consistency of paint.

From there, load your flat brush with clean water and distribute it in the area above the pencil line. Make sure to soak up any excess puddles of water that might gather around the edges with a tissue or paper towel to prevent the paint from spreading out uncontrollably later.

Then load your round brush with paint and apply it right at the top of the paper. From there, distribute it slightly downward while following the shape of the curve below.

Step 2

Now you want to loosely transition from the very saturated and dark to a light value of blue-colored paint in two stages.

First, rinse your brush and remove some of the excess water by gliding it over the edge of your water container and a little bit over a tissue.

Then place your damp brush on top of the edge of the painted area and blend it out downward and by following the curve below again.

Before you reach the curved line, stop, rinse your brush again and remove excess moisture so you can use a damp brush again. Then blend out the rest of the paint toward the pencil line.

While the paint is still wet, move on to the next step!

Step 3

To make the ocean more turquoise, you can add a little bit of Lemon Yellow to the paint. This way you can not only adjust the colors but create additional small waves in the water.

For this step, load your clean round brush with a little bit of concentrated Lemon Yellow and blend it right into the center of the blue-colored area. Remember, you don't want to add additional watery paint on top of the wet paint. If the second color you add on top is too diluted, it will spread out too much and cause unwanted backruns and patchy results, so remove any excess moisture from your brush if needed.

Then blend out the color upward and downward, so you add a little bit of the turquoise mixture to a few different areas.

From there, rinse your brush, remove excess moisture and use an almost-dry brush to blend some of the paint downward, but above the pencil line. This is going to be the foamy part that you'll work on in the next step!

Then let everything dry completely!

Step 4

Once everything is dry, it's time to paint the sand!

Create a little puddle of water in your mixing palette. Add Yellow Ochre and dilute it to create a light value of paint.

Then use your round brush and apply a flat wash right below the lightest value of blue, while leaving out space in between to keep a little bit of the white area for the foam.

With the leftover paint on your brush, lightly brush the paint over the lightest value of blue-colored paint, just to make the sand appear a little bit visible through the water.

While the paint is still wet, load your round brush with more Yellow Ochre. This time you want to use a more concentrated color by using more pigment than water.

Add a few horizontal streaks to the sand to add some dimension. Remember, you only want to add more pigment on top, not additional water—otherwise the paint won't blend smoothly.

Then let everything dry completely again.

Step 5

Once the paint has dried, use a light value of Yellow Ochre again and apply it right below the white foam area for shadow to add depth.

To make the ocean and beach look more fun, you can now add a few colorful umbrellas! To make them stand out, use either red or orange! I didn't use masking fluid to protect the white paper from the paint because I wanted to use the color underneath to create light reflections.

To create the umbrellas, lightly sketch out the hexagon shape with the HB pencil. Then, load your round brush with Cadmium Red and remove some of the excess paint from your brush. From there, cover the first hexagon shape in paint. Next, use a clean dry brush and lift off some of the paint from the umbrella while keeping a triangle shape in mind. You want to create highlights where the umbrella's highest points are to make it look more three-dimensional. Then repeat this step with the rest of the umbrellas.

Step 6

While the umbrellas are drying, you can also add a few simple dots of paint along the bottom edge of the painting to create some greenery.

For this step, use Cerulean Blue and Lemon Yellow to mix a vibrant green. Then add a little bit of Cadmium Red to make the greenery look more natural by muting the green with its complementary color. You can also mix a little bit of Yellow Ochre into the paint here and there right on the paper to add a few soft golden greens as well.

And you're done!

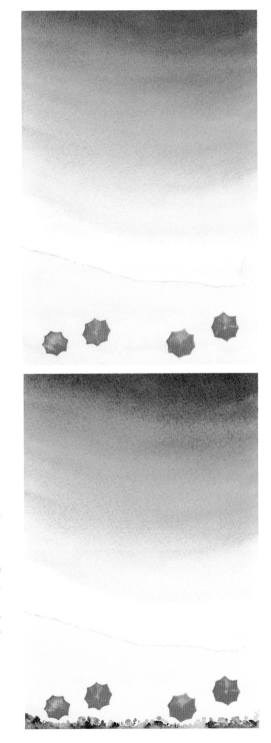

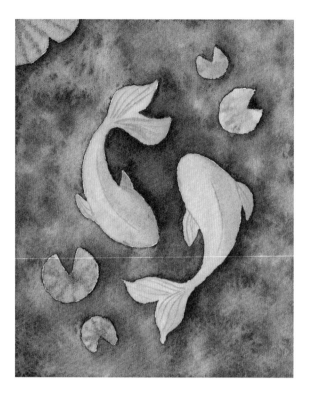

Dancing with the Fishes

●●○ INTERMEDIATE

Painting wet-on-wet opens so many possibilities, especially when you want to add additional elements and texture to your painting! A fun and easy way to add texture in your artwork is by sprinkling a little bit of water on top of wet paint. Instead of adding watery paint onto the wet paint to avoid uneven washes, you can use this technique to your advantage and create light reflections in the water. This is what you're going to do in this painting as you practice your color mixing and harmony knowledge!

Materials you'll need

Masking tape

Watercolor paper

HB pencil

Masking fluid

Small brush for masking fluid

20mm flat brush

Tissues or paper towels

Size 8 round brush

Brush for details (optional)

Colors

 Cerulean Blue

 Lemon Yellow

 Cadmium Yellow

 Cadmium Red

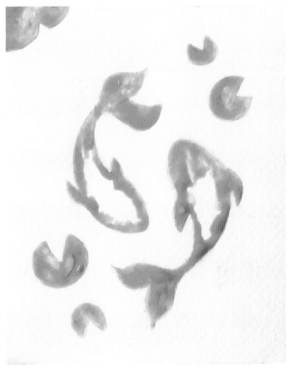

Step 1

Using masking tape, outline a rectangle or square on your watercolor paper. This will be the working area of your painting again. Then tape your paper onto your desk or board.

Lightly sketch out two fish silhouettes in the center of the paper facing each other, as if they're swimming in circles above something that is in the water. Again, you want to think of them as curved drops of water when you create the body. From there, add fins that have a similar shape as leaves. Next, create the lotus leaves by sketching out a circle and leaving a small triangle indent. Change up the size and placement to make the composition look looser.

Step 2

Once you've sketched the outlines, cover them with masking fluid. By using masking fluid, you'll protect the white of the paper as you paint everything around it. This will make it easier to focus on the rest of the painting.

While the masking fluid is drying, it's time to prepare the paint! Create two small puddles of water in your mixing palette. In the first puddle, create a creamy mixture of Cerulean Blue. In the second, create a creamy mixture of Lemon Yellow.

Once the masking fluid is dry, cover the whole area with clean water using your flat brush. Make sure to get the water into every corner. If you see any puddles of water, soak them up with a tissue or damp brush.

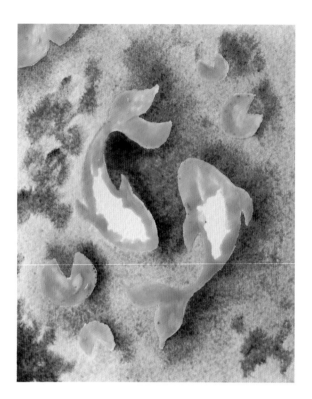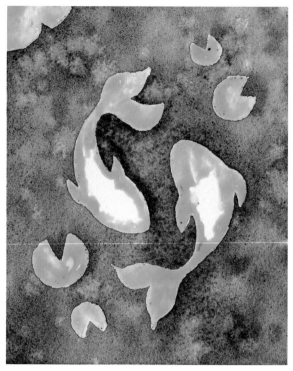

Step 3

While the paper is still wet, start applying wet paint to the paper. To create depth in the painting, start with the dark value of Cerulean Blue and apply it right in the center and to the right side of every object in your painting. Then blend out the paint with the water on the paper.

Step 4

Use the same brush and load it with Lemon Yellow. Then apply it in between the dark blue areas to mix them together to create different shades of blues and greens right on the paper.

Next, rinse your brush and glide the bristles over the edge of your jar to remove a little bit of the excess water, so the brush is not super-soggy. Then hold the brush over your painting as you tap the handle of your brush using your finger. This way, you make the bristles release the water and sprinkle small drops onto the wet paint.

Let everything dry.

Now what happens, since you added water to the concentrated mixture of paint that has started drying, is that the water will push away the pigments and create backruns, also known as the cauliflower effect. Knowing how to avoid or create such an effect can give you so many options to create loose details in your art!

If you have trouble with this, make sure the paint is not too wet when you sprinkle clean water on top, otherwise the effect won't be that noticeable. You can also sprinkle table salt over the image instead to soak up the paint, or use both techniques at the same time and play around with it! Just make sure the paint is not too wet and not too dry or it might not work!

Step 5

Once the first wash of paint is completely dry, carefully rub or peel off the masking fluid. If there are any pencil lines visible, you can erase them.

Because for this painting we used different blues and greens, you can use a lovely bright orange to make the fish stand out.

In this case, I used Cadmium Yellow, but you can also use any other orange or yellow-orange color.

Load your round brush with paint and apply an even wash to the first fish.

To create shadows, use a warm red color; in this case, I used a little bit of Cadmium Red and mixed it into the Cadmium Yellow to make the color darker and more orangey.

While the layer of paint is still wet, apply the paint right along the center of the fish and on the right side. This way this part will look like it gets less light.

Then you want to repeat this process with the second fish.

Once you've painted the fish, cover the lotus leaves in paint as well. For this step, use either a light value of a premixed green or create it yourself by mixing Cerulean Blue and Lemon Yellow.

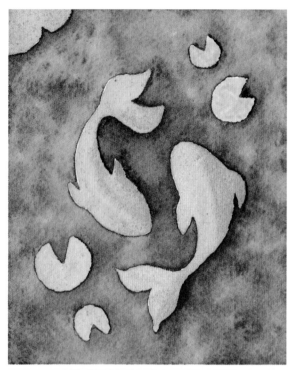

Step 6

Using the detail brush, add more pigment on top of the lotus leaves in a star shape. You can either do that wet-on-dry or wet-on-wet. In my case, the paint was still wet, so I used the wet-on-wet technique to create soft shadows on top of the lotus leaves.

Once the paint for the fish is dry, you can add even more details using a darker value of the orange color.

Simply use the same color you used for the shadows, but this time, apply it using the wet-on-dry technique along the shadow you created earlier, on top of the fins and to the side of the head to add eyes.

Let everything dry, and you're done!

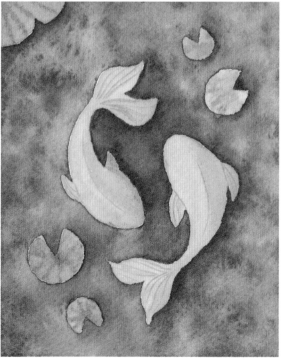

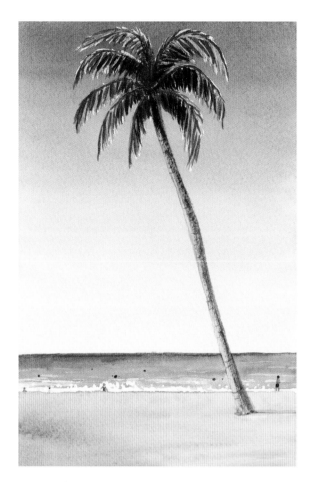

Palm Tree Beach

●●● ADVANCED

With this painting project, you're going to combine multiple techniques. Gradient washes, wet-on-wet and using masking fluid—all of that will make this painting come to life!

For this painting, we don't use the rule of thirds as in the previous paintings. Instead, we use the rule of fourths this time. This means you want to divide the paper equally into fourths, both horizontally and vertically. This way we will have a lot more space to showcase the height of the palm tree! It will help you illustrate the size of the tall palm tree compared to the people around the ocean as the viewer's eye moves up and down your composition.

Materials you'll need

Masking tape

Watercolor paper

HB pencil

Masking fluid

Small brush for masking fluid

20mm flat brush

Tissues or paper towels

Size 8 round brush

Brush for details (optional)

Colors

 Ultramarine

 Cerulean Blue

 Lemon Yellow

 Yellow Ochre

 Burnt Umber

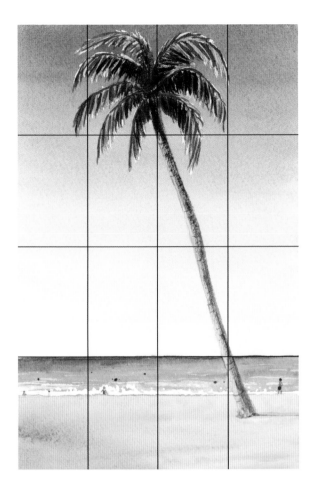

Step 1

Using masking tape, outline a vertical frame on your watercolor paper and tape it down to your desk or board.

Lightly sketch out two horizontal lines: Draw one line across the lower fourth of the painting and another slightly below. This is going to be the area where we paint the ocean and the beach below. Make sure the area for the sea is a lot narrower than the one for the beach.

Since the main subject of this painting is the palm tree, we're going to place it right on top of the intersections, following the rule of fourths. Sketch out a diagonal line starting from the beach area, where the vertical and horizontal lines intersect and then go upward to the upper fourth section.

Now, instead of watercolors, use masking fluid to paint the palm tree leaves and to cover up the trunk, the same way as in the Cotton Candy Clouds painting (page 128). This way we can focus entirely on painting the background first!

From there, paint thin lines on top of the ocean using masking fluid. These are going to be some of the reflections of light on top of the sea. Next create a thicker line, with a few dots here and there, right in between the ocean and beach area. This is going to be the foam of the wave.

Once you've covered all the areas as shown here in blue, let everything dry completely!

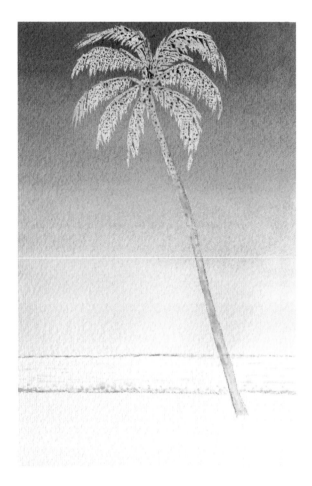

Next, load your flat brush with your concentrated mixture of blue-colored paint and apply it to the upper area of the paper.

From there, move your flat brush from left to right, back and forth as you slowly move your way downward. The water on the paper will help you to dilute the paint and create a transition from dark to light color values.

If you notice you still have way too much paint on the brush, rinse it off and dab off a little bit of the excess water using a paper towel. Then continue blending out the color with your damp brush right where you left off until you reach the horizon.

Don't worry about making the graded wash perfectly even! If you have additional lighter and darker areas here and there, it makes the sky look more lively and less flat!

Then let everything dry completely.

Step 3

Once the sky area is dry, it's time to paint the ocean.

For this step, you want to use the concentrated mixture that you used for the sky again. Load your round brush with paint and create a thick line along the line of the horizon.

Rinse your brush and remove some of the excess water from it by gliding it over the edge of your water container. Then use your damp brush to blend out the blue-colored paint toward the beach area.

You want to create a transition from dark to light as the ocean gets closer to the viewer.

To make the ocean water slightly more turquoise, you can add a little bit of Lemon Yellow to the wet paint by creating a few thin streaks. Remember to remove any excess water from your brush before you apply the paint into the wet wash. Otherwise, you will add too much water on top and create back runs.

Then let the ocean area dry completely!

Step 2

Once the masking fluid is dry, it's time to paint the sky!

For the sky, you want to prepare a concentrated mixture of blue paint to be able to create a graded wash. In this case, I mixed Ultramarine and Cerulean Blue together, but you can use any blue color of your choice.

Load your flat brush with clean water and distribute it all over the area above the first horizontal line. Make sure to remove any excess water with a damp brush or a tissue.

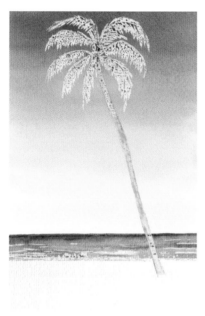
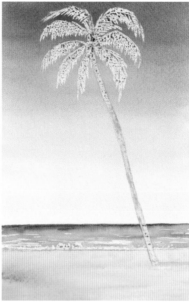
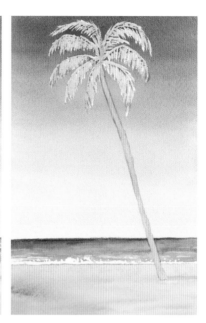

Step 4

Once the ocean has dried, it's time to paint the beach!

For this step, load your round brush with a light value of Yellow Ochre and apply a flat wash right below the ocean.

While the paint is still wet, load your brush with more Yellow Ochre, but this time you want to use a lot more pigment, so the color is concentrated. Then add a few horizontal streaks to the sand to add some depth. If you want to make some areas even darker, add a little bit of Burnt Umber into the mix!

Here I applied the paint closer to the viewer and on the right side of the tree to create the shadow.

Then let everything dry completely again.

Step 5

Once the paint has thoroughly dried, carefully rub or peel off the masking fluid. Then it's time to paint the palm tree!

For the palm tree leaves, you want to use many different greens.

Here I mixed Yellow Ochre with my blue mixture to create a very light value of this olive green color. Load your round brush with a fine tip or your brush for details with the warm green color and paint the blades in the same way that you applied the masking fluid.

Don't worry about covering all the white space with paint! If you keep a few white areas here and there, it will look like strong light is hitting the leaf.

Then cover the palm tree trunk with a light wash of Burnt Umber.

Because I felt like my ocean was a little bit too light after the paint dried, I carefully applied a little bit more blue color around the horizon, then I carefully blended it out toward the beach.

Then let everything dry completely!

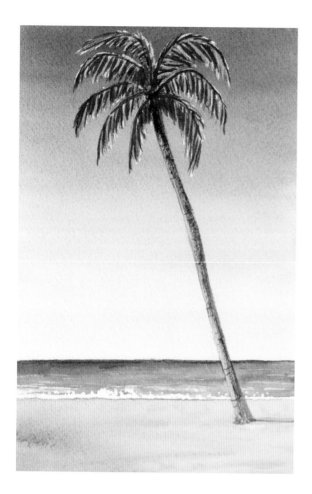

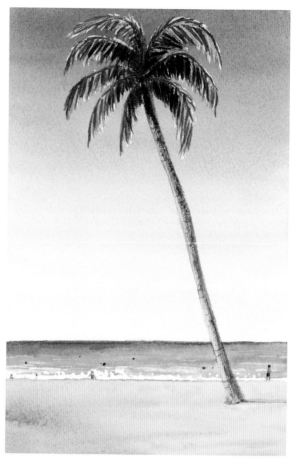

Step 6

Once the paint has dried, it's time to finalize the painting!

To add shadows to the palm tree, continue building up different green-colored blades in the same way as in Step 5. Here I mixed different types of green using Lemon Yellow, Yellow Ochre, Cerulean Blue, and Ultramarine while changing up their values.

To make the tree trunk less flat, let's add some shadows and details!

First, use the dry brush technique to lightly brush on the texture of the tree using Burnt Umber again.

Now, to make the shape more round, you want to use a dark value of the same color. Load your brush with paint, and as you follow the round shape of the tree, paint small c-shaped curves here and there along the tree trunk to make the tree look three-dimensional.

Then use the same color and add another layer of paint to create a shadow in the sand the same way that you did earlier with the Yellow Ochre.

Now, you can either keep the painting as it is, or you can also add a few small people that make the whole scene more lively!

Step 7

To paint people in your painting, you don't have to get lost in all the details!

Focus on simple shapes and add a few dots of color here and there. In this case, I used a dark value of Burnt Umber to create dark dots in the water that are swimming far away in the ocean.

For the people in the front, I used Yellow Ochre and a little bit of Burnt Umber to create simple silhouettes. One person is sitting, the other is walking or standing. From there, I used different colors to paint the swimsuits!

Don't worry about making them super realistic! You just want to capture this moment and suggest that there are people that are enjoying the ocean!

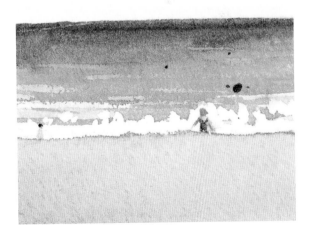

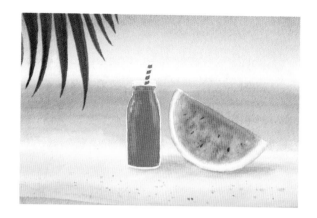

Enjoying Watermelon at the Beach

●●● ADVANCED

Now that you know how to create depth and distance using different types of washes and details, it's time to put everything together!

In this painting, you're going to paint a hot sunny day with a refreshing drink and watermelon at the beach!

Materials you'll need

Watercolor paper

Masking tape

HB pencil

Masking fluid

Brush for masking fluid

20mm flat brush

Tissues or paper towels

Size 8 round brush

Colors

 Ultramarine

 Cerulean Blue

 Lemon Yellow

 Yellow Ochre

 Carmine Red

 Cadmium Red

 Burnt Sienna

 Burnt Umber

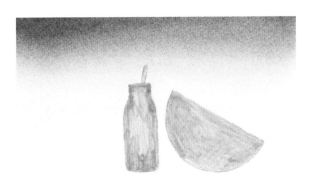

Step 1

For this painting, we're going to use a horizontal format to have space for the background, foreground and a few additional details. Outline a rectangle on your watercolor paper using your masking tape and tape it down to your desk or board.

Now, following the rule of thirds, lightly sketch out a simple outline of a bottle and a slice of watermelon. Think of the watermelon as a circle and then divide it in half diagonally.

To create the bottle, imagine two rectangles. One horizontal rectangle is the opening and the second vertical rectangle shapes the bottle. Then connect both parts together with diagonal curved lines. If you want, you can add a small straw on top as well!

Once you've lightly sketched out the outlines, cover them with masking fluid. This way, we can focus on the background first, without worrying about painting over these objects.

Then let the masking fluid dry completely!

Step 2

While the masking fluid is drying, let's prepare the paint!

For the sky, prepare a concentrated mixture of Ultramarine mixed with Cerulean Blue in your mixing palette. We're going to use it to create a graded wash from dark to light as the sky fades out into the horizon.

For the ocean, mix Cerulean Blue and Lemon Yellow together to create a turquoise color of creamy consistency. Remember to use more blue than yellow to make a greenish-blue.

For the beach, prepare a light value of Yellow Ochre for the first wash.

Once the masking fluid is dry, it's time to paint the background!

To blur out the background to emphasize the distance, we're going to use the wet-on-wet technique.

Load your flat brush with clean water and apply it on top of the whole painting area. Make sure to distribute the water evenly and to remove any excess water using a damp brush or a tissue. If your paper tends to dry really quickly, apply another layer of water the same way after giving your paper time to absorb the first wash of water.

Once the paper surface looks slightly less shiny, load your round brush with the mixture of Ultramarine and Cerulean Blue and apply a graded wash from the top to the first third of the paper.

Step 3

Next, load your clean damp brush with the concentrated turquoise mixture and apply it right below the white area of the sky and above the lower third of the painting.

If you notice that the paint spreads out too much, don't worry! Simply rinse your brush after you've applied the paint, soak up the excess moisture, and use the damp brush to soak up some of the wet paint along the edges.

Repeat the same method with the beach. Load your clean round brush with Yellow Ochre and apply a flat wash of paint to the lower third of the paper while leaving out a little bit of space in between the ocean and the beach.

Step 4

Next, load the same brush with more pigment of Yellow Ochre and apply the paint to a few areas to create some shadows.

Here I applied the paint to the foreground and on the right side of the objects. If you want to make the shadows slightly more realistic, you can quickly add a little bit of red and green to the wet paint on the paper.

Here I used Carmine Red and a green made of mixed Cerulean Blue and Lemon Yellow, but you can use Sap Green for that as well! This way you add the colors of the bottle and watermelon that reflect onto the sand.

Let everything dry completely! Once the paint has dried, carefully rub or peel off the masking tape to reveal the white paper again.

Step 5

Now it's time to paint the watermelon! First, load your brush with a light value of Cadmium Red or any other red you have. Then paint a semicircle inside the white shape while leaving space in between the rind. Then, use a damp brush to soften the edge to create a gradual transition from a dark to light value.

From there, load your brush with additional pigments and dab them onto a few areas on top of the red wash to add some depth. To make the watermelon look juicier, make the center of the watermelon darker compared to the area around the rind.

Now to create the texture of the watermelon we're going to use the cauliflower effect again. Before you do that, make sure the wet paint is slightly damp. If you apply water to the wet paint immediately, you'll just overflow the pattern and make it disappear. Then dip the tip of your clean wet brush to a few areas on top of the damp paint to make the water slightly push the pigments away.

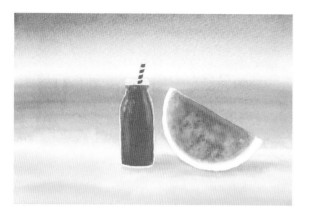 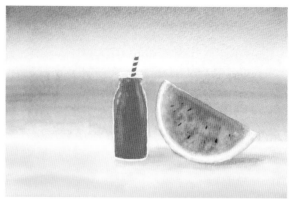

Step 6

While the inner part of the watermelon is drying, it's time to paint the bottle!

Here, you want to apply a flat wash of a concentrated mixture of Cadmium Red using the wet-on-dry technique. Keep the very edge of the bottle white to show the thickness and transparency of the glass bottle. This way, the bottle will look less flat and more realistic.

If you want, you can also add a little bit of Carmine Red to the center of the bottle, just to make this area slightly darker and to add dimension. From there, lift off some of the wet paint on the left and right side as you follow the shape of the bottle, using a clean damp brush to create some light reflections. I also used the same color, Carmine Red, to create a stripy design on the straw, but you paint it however you like!

To make the bottle look even more realistic, you can paint additional lines inside the opening of the bottle using the same color that you used for the ocean. This way, it will enhance the transparency of the bottle, as if the blue ocean is shining through.

Then let everything dry completely!

Step 7

Once the paint has dried, it's time to add some details!

Let's start with the watermelon!

Mix a little bit of Lemon Yellow and Cerulean Blue to create a light value of green or simply use a pre-mixed green! From there, add a thin line across the lower edge of the watermelon to create the rind. Here I also added additional darker lines on top that are spaced out, to make the pattern of the watermelon skin look more realistic.

Next, use a very dark value of Burnt Sienna to paint a few small seeds on top of the watermelon using the tip of your round brush. Make sure you don't place the seeds in one row and in one size. Switch it up, otherwise it will look less realistic!

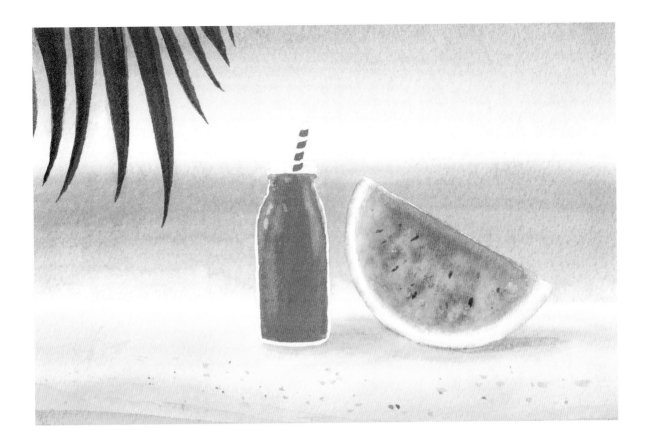

Step 8

To bring the beach area more in focus, let's add a few small details here as well!

Switching between Burnt Umber and Burnt Sienna, add a few small dots and lines here and there using the tip of your round brush. These can be small stones, pieces of plants, or anything else! We just want to create the impression of a beach!

This will emphasize the contrast between the blurry ocean in the background and the foreground with its sharp outlines, making it the focus of the painting.

Last but not least, you can also add a few leaves of a palm tree to the upper-left corner in the same way as in the Monochromatic Beach Sunset (page 66). Here I mixed Ultramarine and Lemon Yellow to create a dark value of green, but you can also play around with Yellow Ochre and mix it with Ultramarine or Cerulean Blue as well!

Let everything dry, and you're done!

Dreamy Night Skies

Next to the sea, painting different skies is so fun and therapeutic as well! It's also another one of the elements of a landscape painting. With the next few projects we're going to explore different elements of a dreamy nighttime sky that you can use in your paintings. You'll practice color mixing, water control and how to blend different colors together without creating muddy results. You'll also learn how to use white gouache, the sponge and the dry brush technique to effortlessly add details to your paintings!

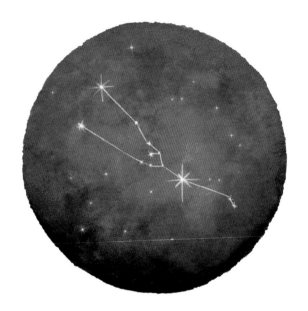

Lost in the Galaxy

● ○ ○ BEGINNER

A great way to explore color mixing and the wet-on-wet technique is by simply playing around with different colors! Watching the paint move and blend is so fun!

For this painting project, we're going to create different colored backgrounds that you can use for so many different things—from galaxies to planets to skies! And the easiest way you can avoid muddy colors is when you use colors that are close to each other on the color wheel. When mixed, they create different variations of those colors. In this case, we're going to use two different reds and a little bit of Payne's Gray to create darker areas, but you can also use any other color combination using the monochromatic or the analogous color scheme!

Materials you'll need

HB pencil

Watercolor paper

A round bowl, cap or anything else that you can use to trace a circle

Size 8 round brush

Tissues or paper towels

Colors

 Carmine Red

 Quinacridone Rose

 Payne's Gray

White gouache or white acrylic

Step 1

First, trace or draw a circle onto your watercolor paper. This is going to be our painting area.

Now with the wet-on-wet technique, you want to pay attention to two things: how much water you have on the paper and how much water you have on your brush.

To make the paint blend just slightly, you want to make sure the paper is damp and that you use paint with a concentrated amount of pigment.

The more watery the paint, the more it will spread.

Load your round brush with clean water and distribute it inside the circle. Make sure you apply the water as evenly as possible, meaning that if you see any pools of water, either soak them up with a damp brush or distribute them to any dry area. You want your paper to have an even shine of water, so the paper can evenly absorb some of the moisture.

Next, load your brush with a concentrated mixture of Carmine Red or any other red color of your choice.

Once the paper has lost its shine and looks rather dull, apply the paint to the edge of the circle. As you do that, keep the paper white in the center.

Because the paint should be creamy, it won't spread as much on the damp paper, and this is precisely what we're going for!

Step 2

Next, rinse your brush and remove excess water using a paper towel or a tissue. You don't want to add additional water onto the paper, since it will push away the drier paint.

From there, load your brush with a concentrated mixture of Quinacridone Rose and apply it right in the center of the circle, making both colors blend.

Slightly move your brush around the edges of those colors to lightly make them blend. This way we get a pinkish red as a highlight and another deep red around it.

Step 3

While the paint is still wet, you can add some additional depth!

In this case, load your round brush with Payne's Gray that has a creamy consistency and apply it right at the bottom of the circle.

After that, lightly blend the paint into the red color next to it.

Using black for shadows can make the painting look more dull, that's why a lot of artists prefer mixing their own colors for shadows, but in this case, you're just playing around with paint as you get more and more familiar with this medium!

Step 4

Once the paint has dried, you can use this background for so many different things!

In this case, I used white gouache to paint a few small stars and the constellation Taurus. But you can also paint different zodiac stars and symbols!

You can use this technique to get familiar with all the colors you have! As you can see here, I played around with the monochromatic and analogous color schemes to create these small planets. You'll be surprised what colors you can create with this exercise!

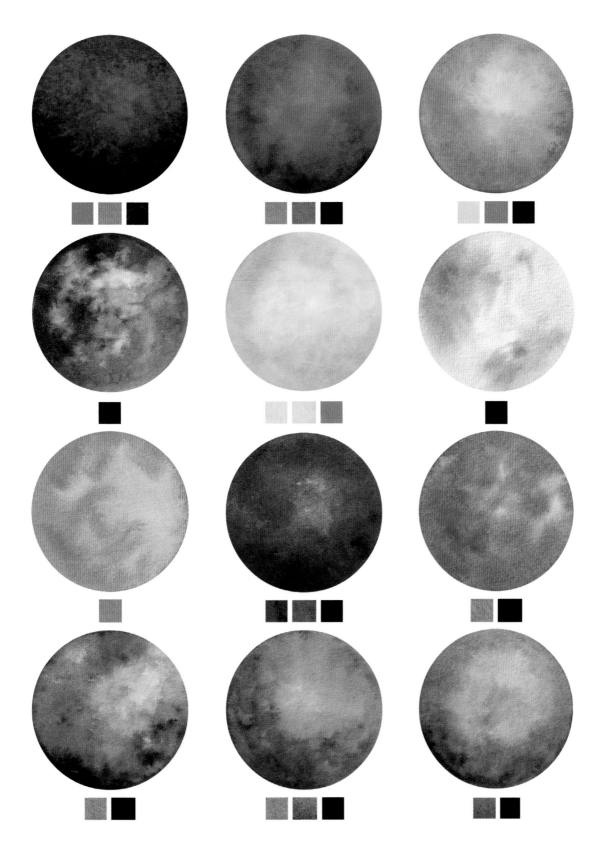

To the Moon and Back

●●○ INTERMEDIATE

Painting wet-on-wet not only allows you to smoothly blend colors or mix them together, but also to create depth by adding different textures to your painting.

In this painting project, you're going to paint the moon in just a few steps using only one color! This way you get to continue to practice your paint-to-water ratio and wet-on-wet painting skills. Remember, with the wet-on-wet technique, you want to pay attention to two things: how much water you have on the paper and how much you have on your brush. To make the paint blend just slightly, you want to make sure the paper is damp and that you use paint with a concentrated amount of pigment whenever you want to add more paint on top. The more watery the paint, the more it will spread—so make sure to read the instructions first so you're ready to go and know what to expect!

Materials you'll need

HB pencil

Watercolor paper

A round bowl, cap or anything else that you can use to trace a circle

Size 8 round brush

Tissues or paper towels

Colors

Payne's Gray

Step 1

First, trace or draw a circle onto your watercolor paper. This is going to be your painting area.

Then create a small puddle of water in your mixing palette and add a little bit of Payne's Gray or any other black color to dilute it. You want to create a light value. Remember, the more water you use compared to pigment, the lighter the colors and the more watery the consistency will be.

Test out the color on a separate piece of paper to make sure it's not too light or too dark. Remember, watercolors look lighter when dry, so make the value slightly darker than how you'd like it to look.

Next, load your round brush with the paint that you just prepared and apply it on top of the circle. Make sure to distribute the paint evenly and to remove any puddles of excess water using a damp brush or tissues.

If you notice that some areas on your paper have started drying because they're not shiny anymore, simply go over these areas with water again, then evenly blend everything together.

While the first wash of paint is still wet, move on to the next step!

Step 2

Now add more Payne's Gray to the pool of water you created earlier to make the solution more concentrated. If you've run out of it, don't worry! Simply add a little bit of water to your mixing palette again and mix the pigment into the water.

Once the paper looks rather dull and not shiny anymore, load your round brush with the concentrated mixture of Payne's Gray. Then remove any excess moisture from the brush by lightly touching a tissue.

Next, press your brush down to a few areas inside the circle and lift off your brush quickly, so you don't release too much of the paint. This way you create simple round shapes that look similar to craters that you can see on the moon. Here I created a few on both sides of the circle while keeping the lower half empty.

Don't worry about making them exactly like the moon! The goal here is to simply practice the wet-on-wet technique as you create texture inside the circle.

Use the leftover pigment to paint a few curved lines on the bottom half of the moon. Start at the big craters and move your way downward toward the bottom and repeat it on both sides.

Step 3

Rinse your brush and soak up the moisture from it using a paper towel or tissues.

Now you want to use your dry brush to lift off some of the paint to reveal the white paper below. This will add a few additional details.

Use the tip of your brush to carefully lift off the paint by creating a shape similar to a firework. Each time you remove the color by creating one curved line, remove the pigment from the brush with a tissue. You want to continue using your clean, dry brush to lift off the paint.

If you feel like your paint is too dry to use this technique, don't worry! Simply use a damp brush to carefully reactivate the color by creating the same lines. Then use a dry brush again or a tissue to remove the paint from the paper.

Here I also created a few white dots the same way, just to add a few more details.

Then let everything dry completely!

Step 4

Once everything is dry, you can use the wet-on-dry technique now to add a few small dots here and there using Payne's Gray again.

And the moon painting is finished!

With this technique, you can create different moon phases! Again, don't worry about making the moon look exactly like your reference. Use the reference to inspire your painting, not to simply copy it!

Cloudy Starry Night Sky

● ○ ○ BEGINNER

Night skies can not only look calm, but also magical! With this painting project, you'll learn how to build up your painting, layer by layer, as you add more and more details that'll make everything come together! One of the tools will be a sponge, which is a great way to lay down paint fast to create not only texture, but also to create trees in a super-easy way. Another easy trick is the dry brush technique that you'll use to create simple mountains covered in snow.

Materials you'll need

Masking tape

Watercolor paper

Size 8 round brush

Tissues or paper towels

Small piece of a sponge

Colors

 Ultramarine

 Payne's Gray

 White gouache or acrylic paint

Step 1

Using masking tape, outline a rectangle on the watercolor paper. This will be the working area of your painting. Then tape the paper onto your desk or board.

Then load your wet round brush with Ultramarine. Here I picked up the pigment straight from the pan to get a very concentrated color.

Now begin distributing the paint starting at the top of the paper by moving your brush from left to right, back and forth while moving downward until you reach the center of the paper.

Step 2

Next, rinse your brush, load it with clean water and remove excess water by gliding the brush over the edge of the container. Then place your brush slightly above the edge of the paint and use the pigment on the paper to blend it out as you move your brush downward to create a graded wash.

From there, rinse your brush again and dab off excess water from it using a tissue. Then go over the whole layer of paint again, starting at the top using your damp brush. This way you pick up some of the paint that is on the paper and move it downward into the lighter area below while moving your brush diagonally back and forth.

Once you reach the lower half of the paper, use the pigment on the brush to create diagonal lines to add depth and movement to the background.

While the paint is still wet, move on to the next step!

Step 3

Load your brush with Payne's Gray, so that you have a creamy consistency. Remember, the more pigment you use compared to water, the darker and more concentrated the color will be!

With this color, you're going to create the clouds.

For this step, paint thin diagonal lines across the upper half of the paper while leaving out some of the blue paint in between.

As you can see in my painting, I created three lines on the left by moving my brush from left to right. To create the transition from thick to thin brush strokes, lift your brush as you reach the center of the paper.

Then I placed another three black lines right in between by moving my brush from right to left, the same way.

While the paint is still wet, move on to the next step!

Step 4

Rinse your brush and dab off excess water using a tissue.

Now you want to use your damp brush to lightly blend out the black lines of the Payne's Gray into the blue color, starting at the very edge of the paint area. This way you only blend out a little bit of this color.

Once you've done this with one of the lines, clean your brush again, remove any excess water using a tissue and repeat this step with the rest of the lines.

When you blend out the bottom line, use the leftover pigment on your brush to blend slightly toward the bottom of the paper to make the light blue color darker.

As you can see, the blue layer of paint became darker in a few areas, while some lighter areas are shining through.

Now let everything dry completely.

Step 5

Once everything is completely dry, it's time to add stars to the sky!

For this step, you can use the tip of your round brush and carefully place some different-size dots in the blue areas of the sky with white gouache.

If it's easier for you, you can also use a small detail brush or a toothpick! Just make sure to change up the size and the position of the dots, so it looks more interesting!

And then let everything dry again!

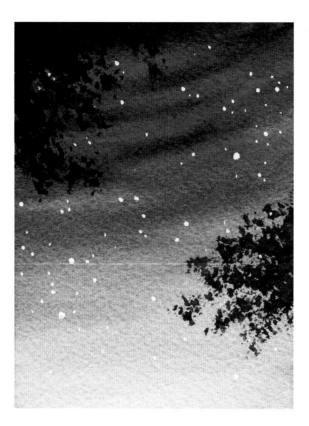

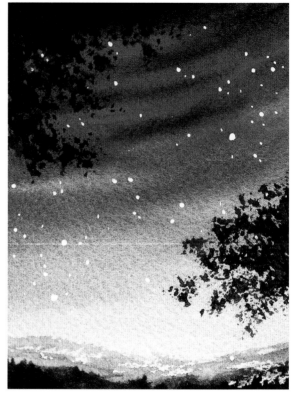

Step 6

Now it's time to make the scenery look more interesting by adding the top of the trees using the sponge technique (page 37)!

For this step, dip the edge of your sponge into the water and squeeze it out so the sponge is not too wet. Then dip it into a creamy mix of the darkest value of Payne's Gray. Before you apply the paint to your painting, test it out on a separate piece of paper so the sponge is not too dry or too wet.

From there, start lightly dabbing the sponge to the upper-left and lower-right side of the painting. For this design, think of it as a firework. Apply more paint to the crown of the tree and space out the texture as you move to the sides.

Once you've created the texture for the trees, you can use the tip of your round brush to paint thin lines inside to create a few branches!

Then let everything dry again and move on to the next step!

Step 7

To make the whole painting come together, let's add a mountain and a silhouette of simple trees to the background.

To create the mountains, we're going to use the dry brush technique (page 36). First, load your wet round brush with a light value of Payne's Gray and dab off excess water using a tissue or paper towel.

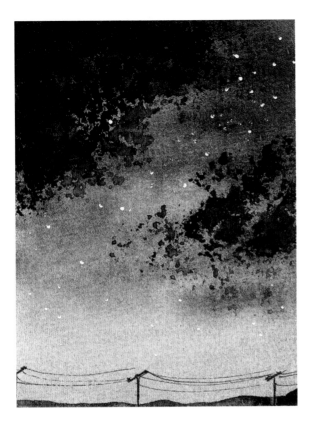

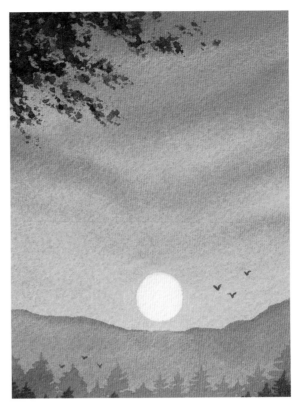

Then hold your brush slightly slanted and quickly brush it over the lower area of the painting while shaping a wavy line. You want to cover some of the areas of the paper in gray, but also leave some areas empty. The dry brush will help you with that!

Because we used the dry brush technique, the paint will dry really quickly. This means you can now load your brush with a concentrated, creamy consistency of Payne's Gray again to create a black silhouette of simple trees right below the mountains. Change up the height and add a few additional lines along the edge to make them look like the tips of trees.

And you're done!

With this technique you can create so many different paintings!

Alternative 1

Instead of only painting a mountain, you can also add power lines across the lower part of the painting using either a small detail brush or a black fine liner!

Alternative 2

Or you can turn it into a sunset scenery! Here I used Cadmium Yellow and Quinacridone Rose to create the transition between yellow, orange and red and used a coin wrapped in a tissue to lift off the paint to create the sun.

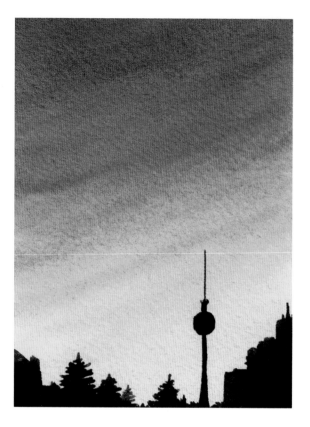

Cloudy Sunset Sky

●○○ BEGINNER

In this painting project, we're going to use three primary colors: yellow, red and blue. This triad of primaries is prone to producing mud when mixed together. An easy way to avoid muddy results when working with multiple colors like these is to make sure you only mix colors together that create bright results. In this case, I chose Ultramarine and Quinacridone Rose to create a bright purple. While Quinacridone Rose will create a bright orange when mixed with Lemon Yellow or Cadmium Yellow, you want to make sure you don't accidentally add the blue and purple into the yellow and orange!

Materials you'll need

Masking tape

Watercolor paper

Size 8 round brush

Tissues or paper towel

Colors

Lemon Yellow

Quinacridone Rose

Ultramarine

Payne's Gray

Step 1

Using masking tape, outline a rectangle or square on your watercolor paper and tape it down to your desk or board. This will be the working area of your painting. In this case, you're going to use a vertical form to have more space for the sky.

Before we start, prepare the paint in your mixing palette. For the sky, you're going to need a concentrated mix of Lemon Yellow or any other yellow you have, Quinacridone Rose or Carmine Red and Ultramarine.

Then load your round brush with Lemon Yellow and start distributing it, starting at the bottom of the paper. Move your brush from left to right as you move your way up diagonally until you reach the top third of the paper.

While the paint is still wet, move on to the next step!

Step 2

Rinse your brush and remove any excess water using a tissue.

Then load your damp brush with Quinacridone Rose and apply it slightly above the yellow wash of paint.

Then lightly blend it upward and downward as you move your brush diagonally over the paper to create a transition between red, orange and yellow.

While the paint is still wet, move on to the next step!

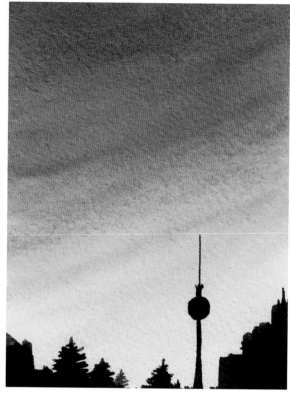

Step 3

While the paint is still wet, rinse your brush, remove excess water and load it with Ultramarine.

Then apply it right above the Quinacridone Rose and lightly blend it downward to blend both colors together, the same way as in the previous step.

To avoid muddy results, you don't want to mix in the blue nor the now-mixed purple into the orange part of the painting—so stop right before that.

Then let everything dry completely!

Step 4

Once everything is completely dry, it's time to add some details!

Using the darkest value of Payne's Gray possible or a fine black liner, paint a silhouette of trees and houses by painting triangles and square shapes.

If you want, you can also add a TV tower to the lower-right side of the paper, just to add an eye-catching element to the painting.

And you're done!

Alternative

With this technique, you can play around with how you apply the paint. In this example, I used the same colors, just placed them horizontally.

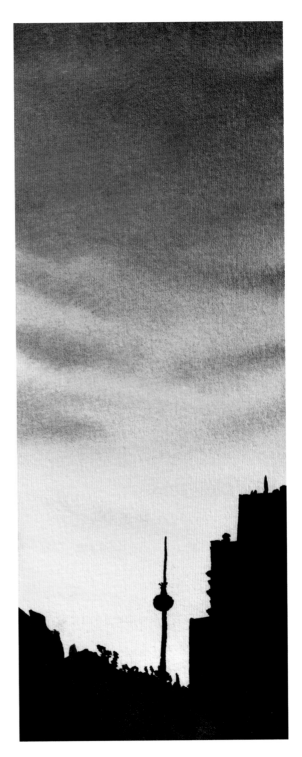

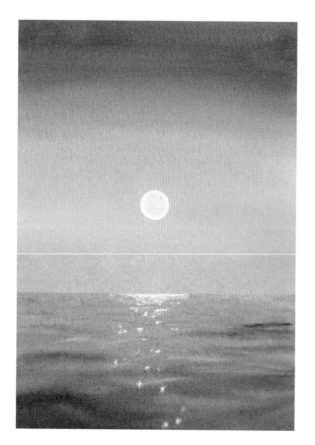

Magical Ocean Moonshine

●●● ADVANCED

In this painting project, we're going to take the ocean scenery to the next level! Here you're going to practice the variegated wash using two colors and your wet-on-wet painting skills. This wash is great for any sunsets or sunrises and is perfect as a base for any ocean or lake scenes!

To create the painting, we're going to use the vertical format again, so we have enough space for the sky and the ocean below. You'll also use the lifting technique to create the moon and a little bit of opaque white paint to create some sparkles on top of the water! Remember, with wet-on-wet techniques, you want to work fast and pay attention to the wetness on the paper and on your brush!

Materials you'll need

Masking tape

Watercolor paper

20mm flat brush

Tissues or paper towels

Small coin

Size 8 round brush

Colors

 Ultramarine

 Quinacridone Rose

 Lemon Yellow

 White gouache

Step 1

Using masking tape, outline a rectangle on your watercolor paper and tape it down to your desk or a board. This will be the working area of your painting.

Now it's time to prepare the paint! Prepare a concentrated solution of Ultramarine and Quinacridone Rose for the sky and the ocean. To make the sea more turquoise, also prepare a little bit of Lemon Yellow that you can add to your blue-colored paint later.

Next, load your flat brush with clean water and start distributing it all over the paper, moving your brush from left to right, up and down, back and forth to make sure you apply water everywhere. Soak up any puddles of excess water that might gather around the edges.

From there, load your brush with blue paint and begin distributing it, starting at the top of the paper. Move your brush from left to right, back and forth as you move downward to create a graded wash. If you notice your brush still has way too much paint to create the graded wash, rinse your brush, dab off the excess water and use the color that is on the paper to blend out the rest. Once you reach the center of the paper, create another graded wash, starting at the bottom.

Step 2

While the paint and paper are still wet, rinse your brush and load it with Quinacridone Rose. Remember, you want to remove any excess water from your brush before you apply more paint on top!

Then apply the pigment to the center of the paper, right where the paper is lighter. Then blend it upward and downward, so both colors slightly mix to a purple color in between.

While the paint is still wet, it's time to use the lifting technique to create the moon in the next step!

Step 3

To create the moon, wrap a tissue or paper towel around a small coin and tuck the excess paper behind the coin to create a flat, round surface.

Then press the coin down onto the wet paper in the center of the upper half of the image. While the coin is pressed down, the tissue will soak up the wet paint.

Next, lift off the coin to reveal the white area below!

While the paint is still wet, move on to the next step.

Step 4

Now, using a round brush, add a little bit of Lemon Yellow into Ultramarine to make the color slightly more greenish-blue. Next, load your brush with this turquoise-colored mixture and soak up any excess moisture from your brush by gently touching it to a tissue.

Then you want to apply the paint right around the horizon, while moving your brush from left to right and leaving out a few areas so the pink color can shine through.

If the paint spreads too much, don't worry! Simply use your paper towel or tissue to remove even more moisture from your brush. This way you will create the horizon without any hard lines but with a soft edge instead!

Use the same brush and load it with a dark value of the Ultramarine. Apply it to the bottom part of the ocean, but this time you want to leave out the lighter blue areas.

If you want, add a little bit of Quinacridone Rose on top of some of the blue areas to add a few additional purple and pink sky reflections.

Then let everything dry completely.

Step 5

Once everything is completely dry, it's time to add a few moon reflections!

For this step, use a little bit of white gouache and paint thin lines right below the moon.

At the horizon you want to keep the lines close to each other. Once you move toward the viewer, spread them out. If you want, you can also add a few additional cross-shape lines to create sparkles!

Let everything completely dry, and you're done!

Alternative

Feel free to play around with different color combinations and to add additional details to your painting!

In this example I used Quinacridone Rose and Cadmium Yellow to create a variegated wash. Compared to the cool colors that we used to create a night scenery, these colors make the whole atmosphere warmer and friendlier.

From there, I used Payne's Gray to add a silhouette of simple trees and bushes to add a horizon to the painting. If you want, you can even add an additional palm tree to round things out! Think of plam trees as exploding fireworks. It consists of a line for the trunk and multiple arching curves on top, leaning toward different sides.

To create these palm trees, I used the tip of my round brush to create fine lines for the center of each palm leaf using Payne's Gray. From there, I painted each blade one stroke at a time from the center line outward. By doing so, I made sure I painted the blades facing toward the front of the leaf.

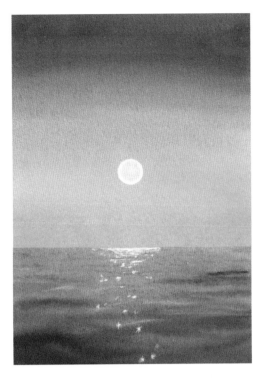

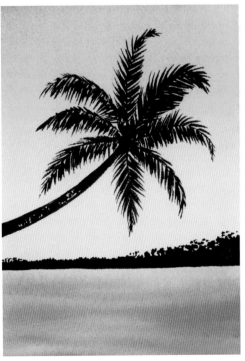

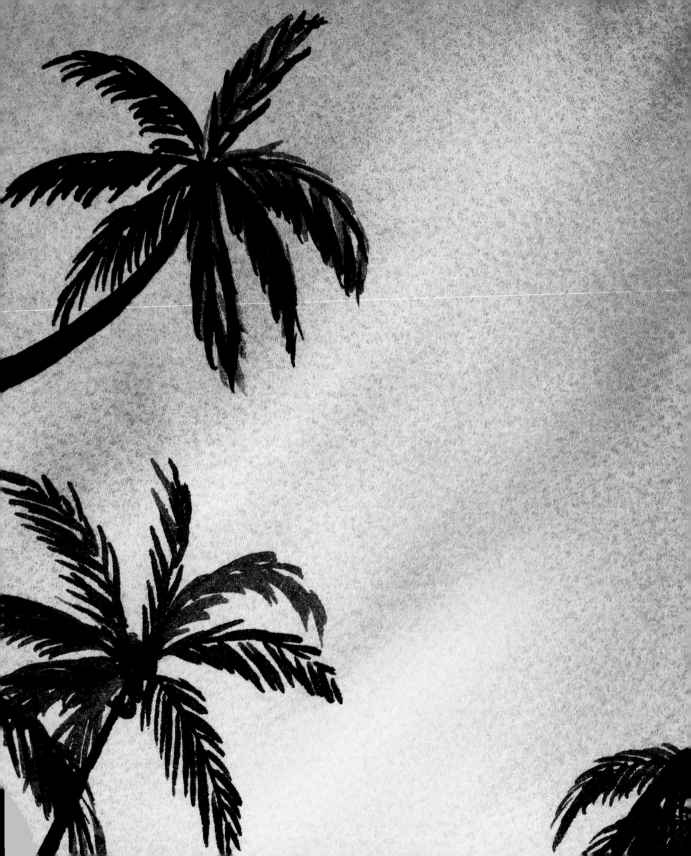

Up in the Clouds

Watching the clouds is always such a fun and beautiful experience. Every time you see something unique! To capture the beauty of the daytime sky, we're going to use the wet-on-wet technique to convey the softness and fluffiness of the clouds. To get started, you're going to warm up by painting simple feathers using the wet-on-wet technique to practice water control and color mixing as you create different textures and effects. This will help you to control how you apply and blend your paint to create soft transitions between different colors. Let's get started!

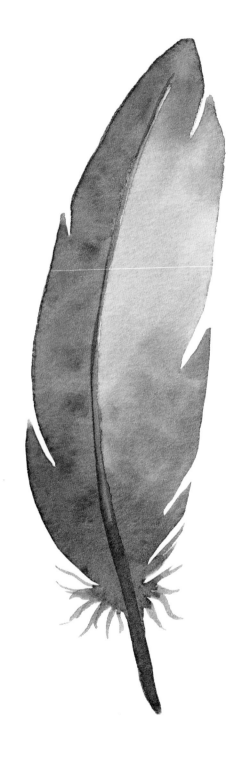

Feathers

● ○ ○ BEGINNER

Feathers are not only fun to paint, but also a great exercise to practice the wet-on-wet technique as you blend your watercolors! In this painting project, you're going to practice your water-control skills as you create texture while blending two colors together to create a beautiful feather!

Materials you'll need

HB pencil

Watercolor paper

Eraser

Size 8 round brush

Tissues or paper towels

Colors

 Cerulean Blue

 Lemon Yellow

Step 1

Using your pencil, start off by lightly sketching out a silhouette of a feather. Think of it as a very long oval shape that is slightly curved to the side and has a pointy tip.

First, draw a slightly curved line to create the shaft of the feather. From there, leave out a little bit of space on the bottom of the curved line and then sketch out a long oval shape surrounding the middle line. Then connect it with the line in the center to create the shaft of the feather.

To make the shape look more interesting, add a few small triangle shapes along the edges that are diagonally facing the middle line. This way, you add a few small gaps in between.

Now you can carefully erase some of the pencil lines.

Step 2

Once you've sketched out the silhouette of the feather, it's time to prepare the paint!

For this design, prepare Cerulean Blue paint of a creamy consistency. Then add Lemon Yellow to your mixing palette and mix in a little bit with Cerulean Blue to create a yellowish-green. If you already have a premixed green, you can use it as well!

To create loose transitions between the colors, we're going to use the wet-on-wet technique. For this step, apply clean water inside the outline, while avoiding the middle line. As you distribute the water, some areas on the paper might start drying. In this case, just go over this area with your brush again to have an even layer of water. If you see any puddles of water, soak them up with a tissue or damp brush.

To make sure that the paint blends nicely, wait for the paper to absorb a little bit of the moisture. Let it lose its shine until the paper looks slightly dull or matte.

Once the paper has lost its shine, it's time to paint!

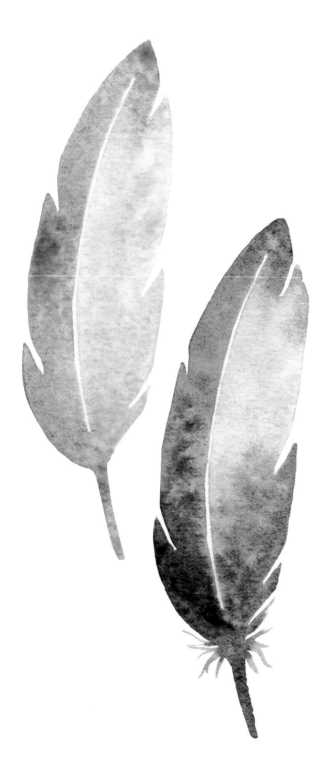

Step 3

Dip your round brush into the yellow-green color. Apply it to the right side of the feather and on top of the upper-left side. The water will dilute the pigment a little bit and make the color value slightly lighter.

Then load the same brush with Cerulean Blue and apply it to the rest of the white paper.

From there, you can move around the paint on the paper and create different shades of blue, green and yellow!

Here I kept the blue wash of paint in the lower part of the feather while I mixed some of the pigments into the green-colored paint. This way I created a dark blue-green color.

While the paint is still wet, move on to the next step!

Step 4

Now it's time to add some additional texture on top using the wet-on-wet technique!

This time, you want to pay attention to the amount of water on your brush when you apply more paint on top.

Remember, whenever you apply another color or more paint on top of a wash, make sure you only add additional pigments and not water. If you add a watery mixture on top of a layer of paint that has started drying, the water will push away the pigments and create backruns. For now, we want to avoid that.

In this case, load your brush with the concentrated mixture of Cerulean Blue that you prepared earlier and remove some of the moisture from the brush using a tissue.

Then start applying small dots of paint on top of the wet paint using the tip of your brush.

Here I added the paint to the left and lower part of the feather while keeping the rest as it is.

From there, use the same color to paint additional feathering around the bottom part.

Use the tip of your brush and paint loose wavy lines facing away from the center. Make some lines go upward, and a few others go downward.

Then let everything dry. To speed up the drying process, you can use a hair dryer!

Step 5

Once everything is completely dry, it's time to add some final details!

For this step, load your brush with green-colored paint and fill in the white line in the middle of the feather. You can use either premixed greens or use Cerulean Blue and Lemon Yellow again.

You don't have to perfectly fill in the line!

If you paint slightly next to the white area, you can create additional depth by overlapping the paint. This way you darken the area and create a shadow next to the shaft.

Your feather is finished!

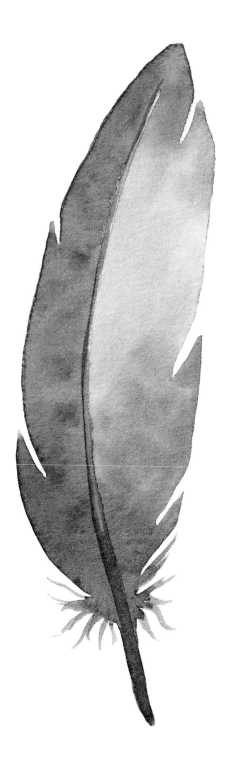

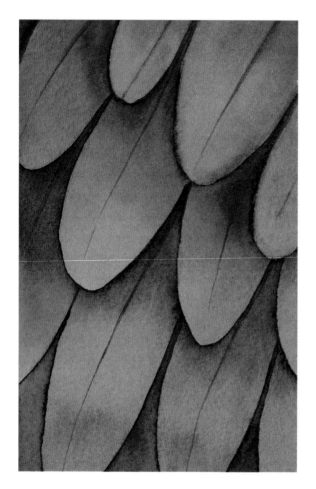

Feather Close-Up

●○○ BEGINNER

The transparent nature of watercolors lets you build your painting layer by layer, making it possible to create different effects. To create this painting project, we're going to use the negative painting technique as we apply one wash of paint at a time. This technique is all about painting around an object with a darker color to make it stand out.

The key to a successful negative painting is to make sure you use light-to-medium values. If you use dark colors too quickly, it will be difficult to create additional depth. Instead, use the transparency of your watercolors to layer them. This way you automatically make your layers gradually darker and darker! That said, make sure you layer colors that are close to each other on the color wheel. This means you should create an analogous color scheme whenever using this technique. If you overlap complementary colors, you'll simply dull your layers.

Materials you'll need

Masking tape

Watercolor paper

20mm flat brush

Size 8 round brush

HB pencil

Tissues or paper towels

Colors

Lemon Yellow

Cerulean Blue

Step 1

Using your masking tape, outline a rectangle on your watercolor paper and tape it down to your desk or board.

Next, create two puddles of paint with a concentrated consistency in your mixing palette, using Lemon Yellow in one and Cerulean Blue in the other. From there, load your flat brush with clean water and apply it all over the paper. Make sure you distribute the water evenly.

Next, load your round brush with Lemon Yellow and cover the lower half of the paper in paint. Then, use the same brush and load it up with Cerulean Blue. Apply it to the upper half of the paper and blend slightly to bring both colors together. This way you create different yellows, greens and blues.

Then let the paint dry completely. To speed up the drying process, you can also use a hair dryer!

Step 2

Once the paint has thoroughly dried, it's time to use your pencil to sketch out the feathers!

Think of them as long oval shapes. In this case, the oval-shaped feathers are short, but then longer and longer each row.

Start at the upper-right corner and outline three oval shapes slightly diagonally.

From there, outline another four oval shapes the same way. This time, instead of simply placing them below the first row, you want to offset them—meaning you want to draw the outlines so that each oval shape starts and ends around the area where the tip of the feather is above it.

Repeat these steps until you reach the bottom of your paper.

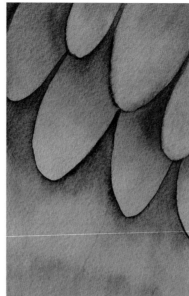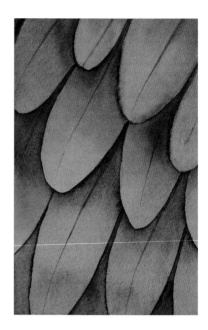

Step 3

Now it's finally time to use the negative painting technique!

As mentioned earlier, instead of painting the shape of the feather that you just sketched out, you want to paint around it.

Load your round brush with your concentrated mixture of Cerulean Blue and outline the first row of feathers. You want to create a thick outline and then blend it out. This way you create the shadows below the feathers.

From there, use a clean, damp brush to carefully blend out the color toward the bottom to keep the area around the feathers darker. Then let everything dry completely again!

Step 4

Once the paint has fully dried, repeat Step 3!

Load your round brush with Cerulean Blue and create a thick outline around the second row of feathers.

Rinse your brush, remove any excess water and then blend out the colors toward the bottom.

Step 5

Once you've created three rows of overlapping feathers and let the painting dry, you can either keep it the way it is or add additional details!

In this case, I used the tip of my round brush and a little bit of Cerulean Blue to create thin lines through the center of each feather.

I made the line thicker at the top and then thinner as I moved downward to the tip.

And the painting is finished!

You can use this technique in so many different ways!

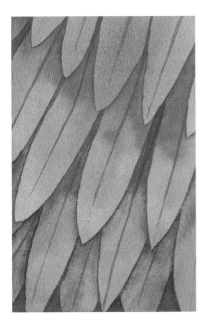
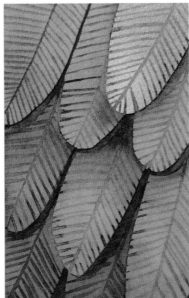
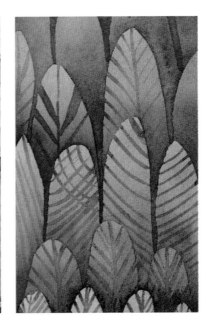

Alternative 1

You can simply change the shape and colors—or paint something completely different!

Alternative 2

Instead of painting feathers, you can turn the same idea into a close up of tree leaves! And these are just a few ideas!

Alternative 3

You can also turn everything upside down and create several rows of trees! The possibilities are endless!

Fluffy Clouds

●●○ INTERMEDIATE

The sky and its clouds are just so magical! They are part of almost any landscape or seascape painting and can be created in so many different ways. For me, painting skies is calming because you get to practice, but also let go. When painting skies, you want to work quickly, prepare your paint in advance and allow the watercolors to do their magic. With this project, you're going to practice exactly these skills as you create these fluffy clouds!

Materials you'll need

Masking tape

Watercolor paper

20mm flat brush

Tissues or paper towels

Size 8 round brush

Colors

 Cerulean Blue

 Ultramarine

Step 1

Using masking tape, outline a rectangle on your watercolor paper. This horizontal format will be the working area of your painting and help you illustrate the movement of the clouds with their curved shapes. Tape your paper to your desk or board.

To have control over how the paint spreads, you want to pay attention to a few things: the amount of water on the paper, the amount of water on the brush and the amount of paint on the brush.

Because timing can be everything in watercolor painting, start off by preparing your paint, so you don't have to stress about it later.

First, prepare a concentrated mixture of any blue color that you want to use for the sky. Use a lot more pigment than water to create a creamy consistency of paint inside your mixing palette. In this case, I mixed Cerulean Blue and Ultramarine together.

Then distribute clean water all over the paper using your flat brush. If you see any pools of water, soak them up using a damp brush or a tissue.

Now pay close attention to the paper. Once you've applied water all over the paper, you'll see a shiny surface. Wait a few seconds so the paper can absorb the moisture a little bit. When the paper loses some of its shine, it's the perfect time to apply the concentrated paint.

For this step, load your brush with the concentrated solution of paint, and paint simple wavy lines diagonally across the paper to create the first outline for the clouds.

Step 2

Once you've applied the paint, you want to work quickly. Load your round brush with paint again without using any additional water and cover the area above the outline with more paint. This is going to be the blue sky behind the white cloud.

The wet paint and damp paper will now work together to create fluffy clouds.

This effect works especially great on 100 percent cotton paper!

Step 3

If you now notice that the lower half of the paper is pretty dry, don't worry! Simply apply more water on top. Be careful when you do that because you don't want to get any water around the area with paint.

Once the paper has absorbed some of the moisture into its fibers again, repeat Step 1. This time, you want to outline another row of clouds, but one that is slightly smaller and closer to the viewer.

Next, rinse your brush and remove excess moisture using a tissue. Then lightly blend out the blue paint on the paper slightly upward to soften the edges even more. If you have any color left on your brush, use it to apply the paint to a few white areas just to add additional shadows.

Step 4

Now just let everything dry completely!

With the wet-on-wet technique, we sometimes tend to keep working and working on the painting instead of simply letting go of it. Let the paint and water do its thing and see what happens!

Using this technique, you can play around with different colors and with the way you apply the paint! Depending on the mood or style you want to achieve, there are so many options!

Alternative 1

Here, for example, I used Quinacridone Rose to outline even more wavy shapes to create the clouds and paint the sky. You can also use white gouache and sprinkle some stars on top or paint the moon to make it look more magical (like in Cloudy Starry Night Sky on page 99)!

Alternative 2

Here I combined both colors. I outlined the clouds the same way as for the project using my blue color. To create the additional shadows, I mixed it with Quinacridone Rose. This way I was able to add a few pink- and purple-colored areas inside the clouds!

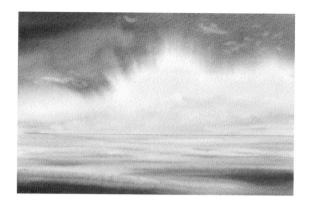

Swimming with the Clouds

● ● ● ADVANCED

Now that you know how to create simple fluffy clouds, why not combine them with a seascape? In this next painting project, you're going to combine the sky with the sea to create a dreamy ocean scene using the wet-on-wet technique.

Materials you'll need

Masking tape

Watercolor paper

HB pencil

20mm flat brush

Tissues or paper towels

Size 8 round brush

Colors

 Cerulean Blue

 Ultramarine

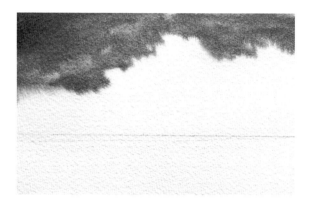

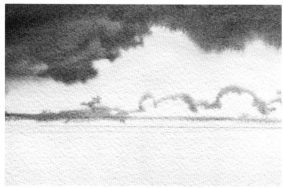

Step 1

Using masking tape, outline a rectangle on your watercolor paper and tape the paper to your desk or board. Next, prepare a concentrated and creamy mixture of any blue color that you want to use for the sky and the ocean. In this case, I mixed Cerulean Blue and Ultramarine together again.

Then, following the rule of thirds, divide your painting area into thirds horizontally. To make it easier for you, you can lightly sketch out the guideline so you know exactly where to apply the paint. From there, distribute clean water all over the top two-thirds of the paper using your flat brush. If you see any pools of water, soak them up using a damp brush or a tissue. Let the paper soak up the water for a few seconds until the paper loses its shine a little bit.

> **Tip:** If you have trouble keeping the paper wet enough, distribute the water, let the paper absorb a little bit and then apply another wash of water. This way you'll give yourself more time to work on the clouds.

Once the paper looks rather dull and no longer shiny, load your round brush with the paint and outline the shape of a cloud. Once you have a simple outline, fill in the top part above the outline using the same color to create the sky.

Step 2

Next, quickly outline another row of smaller clouds below the big cloud and above the horizon. Don't worry about making the clouds look perfect. Then use a clean, damp brush to blend out the outlines toward the big cloud. If you have any color left on your brush, use it to apply the paint to a few white areas to add additional shadows.

Next, to emphasize the fluffiness of the clouds you can use a little bit of water around the edge of the paint. Place a little bit of water along the edges of the blue paint, but not on top of it. This way the water will slightly move toward the paint and lightly push it away. You want to be careful with this though! Make sure you don't add too much water or it will push the paint away too much.

While the paint is still wet, you can also lift off some of the blue paint using a tissue or damp brush to create a few smaller clouds in the sky.

Let everything dry completely.

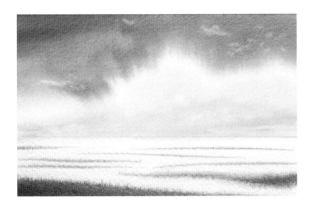

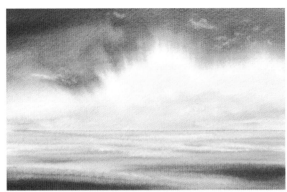

Step 3

Once the clouds are dry, it's time to paint the water below the sky!

Again, start by applying clean water below the horizon line multiple times and let the paper soak up the moisture a little bit.

Load your round brush with the same concentrated mixture of paint that you used for the sky and create thick diagonal lines close to the viewer while keeping space in between them.

From there, paint thin horizontal lines as you get closer to the horizon. Don't forget to decrease the space in between the lines to create the illusion of distance as you move closer to the viewer.

Step 4

Rinse your brush and remove any excess water using a tissue, then use the damp brush to blend out the lines.

Let everything dry completely, and you're done!

Alternative

You can also use the same technique to create a lake scene. Here I used only Ultramarine for the sky and Cerulean Blue for the water. I created the clouds by leaving out more white space, and I added a simple silhouette of dark green trees using Ultramarine and Lemon Yellow across the horizon.

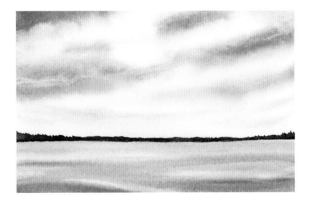

Cotton Candy Clouds

●●● ADVANCED

Now that you have a general understanding of how to paint loose clouds wet-on-wet using only one color, let's add a few more colors to create soft cotton candy clouds! Whenever you paint with multiple colors that you want to blend to create vibrant results, you don't want to choose color combinations that will become muddy. That's why you want to only place colors next to each other that lean toward each other on the color wheel—meaning that if you're going to create a bright purple, place the types of blues and reds next to each other that want to create a bright purple. With this painting project, you're going to practice creating soft clouds using multiple colors, while adding a few simple details to make the sky stand out.

Materials you'll need

Masking tape

Watercolor paper

20mm flat brush

Tissues or paper towels

Size 8 round brush

Colors

Ultramarine

Quinacridone Rose

Lemon Yellow

Payne's Gray

Step 1

Using masking tape, outline a rectangle on your watercolor paper to create your painting area and tape the paper to your desk or board.

Start by preparing your paint first. Create three small puddles of paint with a concentrated consistency using Ultramarine, Quinacridone Rose and Lemon Yellow.

Next, distribute clean water all over the paper using your flat brush. You want to apply it as evenly as possible. Remove any puddles of water by soaking them up with a tissue or damp brush.

Wait for the paper to lose its shine slightly, then load your round brush with Ultramarine. Now instead of creating wavy lines to outline the shape of the clouds, you want to apply the paint where you want the blue sky to be.

In this case, apply the paint to the upper-left corner and to a few areas below while moving your brush diagonally. As you apply the paint, you want to lift off your brush after each brushstroke. This way you transition between thick and thin lines, making the blending of the clouds smoother later.

While the paint and paper are still wet, move on to the next step!

Step 2

Rinse your brush and soak up any excess moisture from your brush using a tissue or paper towel.

Then load it up with Quinacridone Rose. Now you want to apply the paint in between the blue areas. Cover the white space as you move your brush diagonally over the paper in the same way as you did in the previous step. Start in the big white area and then blend out the leftover paint on your brush toward the blue color to create a soft transition between those two colors. This will create a few purple-colored clouds.

Remember to quickly apply the paint and then let it be. Allow the watercolors to do their thing!

While the paint and paper are still wet, move on to the next step!

Step 3

Clean your round brush and remove any excess water again. Then load it with Lemon Yellow and place it on a few areas on top of the Quinacridone Rose.

By applying Lemon Yellow right on top of Quinacridone Rose, you automatically create a more orangey color while still having a hint of yellow here and there.

Remember, whenever you apply another color or more paint on top of a wash, make sure you only add additional pigments, not water. If you add a watery mixture on top of a layer of paint that has started drying, the water will push away the pigments and create backruns.

Let everything dry completely!

Step 4

Once the paint has dried, the colors will look slightly lighter, making the brushstrokes look like soft cotton candy clouds!

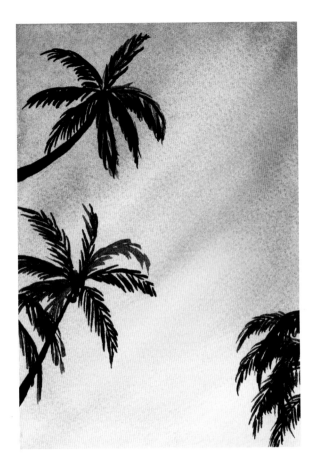

Step 5

You can use this sky as a background for many paintings. For example, you can paint different silhouettes of houses, trees, power lines or something completely different! You can also play around with where you apply the paint using the same techniques.

In this example, I decided to paint a few silhouettes of palm trees.

To make them look like the viewer is looking up to the sky, I placed the shapes at the left and right edges of the painting. This way, they move toward the upper-right corner from the sides, and it looks like the viewer is right below those palm trees.

Think of these palm trees as exploding fireworks. They consist of a line for the trunk and multiple arching curves on top, leaning toward different sides. To create them, I used the tip of my round brush to create fine lines for the center of each palm leaf hanging to the sides using Payne's Gray.

From there, I painted each blade one stroke at a time from the center line outward. By doing so, I made sure I painted the blades facing toward the front of the leaf.

In the example above, I used the same techniques to create a different design for the sky. You can easily add a city silhouette to change it up!

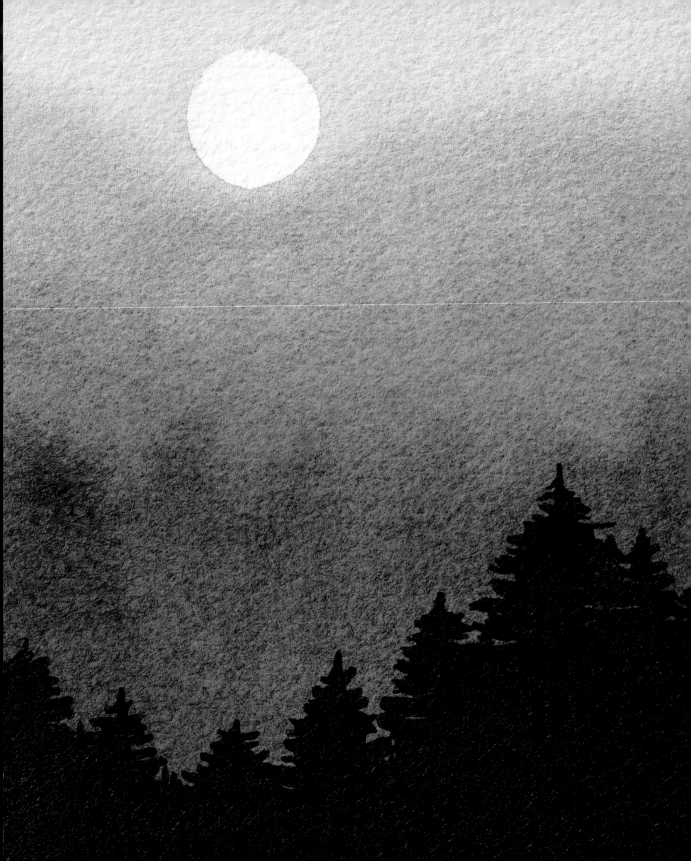

Lost in the Mountains

Connecting with nature can help you relax, recharge and feel creative again! Mountains and trees are one of the main elements of landscapes, and there are so many ways you can paint them! They allow you to practice different basic watercolor techniques to create depth and distance in a simple way.

With the next few projects you're going to practice adjusting the paint-to-water ratio to control water and mix your watercolors while keeping your painting looking harmonious. With just a few additional tricks, such as using a sponge and the dry brush technique, you're going to learn how you can easily make the whole painting come together in a very simple way—one layer at a time!

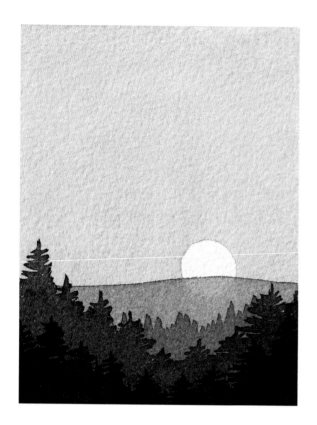

Mountain View

●○○ BEGINNER

With this painting project, you'll get more and more familiar with painting trees and mountains as you practice your layering skills! At the same time, you'll learn how to create depth to suggest distance in your mountain landscape painting.

Materials you'll need

Masking tape

Watercolor paper

Size 8 round brush

20mm flat brush

Tissues or paper towels

Small coin

Colors

Payne's Gray

Step 1

Using masking tape, outline a rectangle on your water-color paper and tape it down to your desk or board. This will be the working area of your painting. Now it's time to prepare the paint!

Start by creating a big puddle of water in your mixing palette using your round brush. Then add a little bit of Payne's Gray with your brush to the puddle to dilute it and create a light value.

Remember, in watercolor painting, the more water you use and the less pigment you add, the lighter the color gets. Make sure the color is not too light by testing it on a separate piece of paper.

Remember: Watercolors look lighter when dry!

Then load your flat brush with paint and distribute it all over the paper to create a flat wash. Move your brush from left to right, up and down and back and forth to distribute the paint as evenly as possible. If you see any darker puddles of excess water and paint, soak them up with a damp brush so the wash can dry evenly.

While the paint is still wet, let's add the shining sun!

Step 2

Wrap a tissue or paper towel around a small coin. Make sure to tuck away the excess paper behind the coin by twisting it together to create a flat, round surface.

Then press the coin down onto the wet paper following the rule of thirds—meaning divide your painting area into thirds vertically and horizontally.

In this case, I chose the lower-right intersection to place the moon, but you can place it in any other place as well!

While the coin is pressed down, the paper towel will soak up the wet paint.

Next, lift off the coin to reveal the white area below!

Let everything dry completely.

Remember, the more watery your mix of paint is, the longer it will take for it to dry. To speed up the drying process, you can use a hair dryer!

Step 3

Once everything is completely dry, add a little bit more paint to the same puddle you created earlier to make the mixture darker. Again, you want to swatch the color to make sure that the new value is darker than the previous swatch of color.

Next, load your flat brush with paint and gently brush over the first layer in a wavy motion right below or slightly over the area of the moon. Then fill out the rest of the paper below.

As you can see, due to the transparency of the watercolor, the moon shines through the layer of paint—and that's the beauty of it! Make sure to distribute the paint gently. If you scrub over the paper too much, you might reactivate the color underneath, and the end result will look uneven.

Remove any excess paint with a damp brush if necessary before you let everything dry.

Step 4

Once everything is completely dry again, repeat Step 3.

Use your round brush to add a little bit more Payne's Gray to the puddle to create a darker value of the same color.

This time you're going to use simple shapes to create a silhouette of trees that are closer to the viewer.

Remember: The closer an object is to the viewer, the sharper the outlines and more saturated the colors become! In this case, the color is getting darker and darker.

Load your brush with paint and hold your brush slightly parallel to the paper, so the tip of the brush is facing upward.

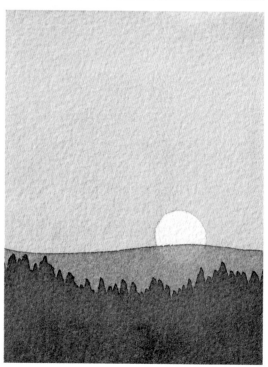

Then place the brush tip below the edge of the mountain, press down, and move it downward to create a triangle shape. Cover the area below with paint. This is going to be the top part of the trees.

Repeat this step for the rest of the trees until you have created another flat wash with the small triangle shapes above.

> **Note:** To make the painting look more interesting, try to make the trees different heights. If the trees are all in one line, the painting can look boring!

And if you're having trouble creating a fine tip, make sure that your brush isn't holding too much paint and water. If that's the case, release some of the color in your mixing palette.

Let everything dry completely.

Step 5

When everything is completely dry, it's time to paint some more trees!

Add more paint to your puddle to make the color even darker and create another row of trees. Start at the left side of the painting and create a thin vertical line using your round brush. From there, create a zig-zag shape starting at the top and that becomes wider and wider. This way you create another simple shape of trees that looks a little bit more realistic. Don't worry about making them super-perfect; you just want to create an illusion of trees without getting lost in all the details!

Once you've created one tree, cover the area below with paint and move on to the second tree. Make sure you don't place the trees in one line, otherwise the painting will look boring. Switch it up! Also make sure you don't cover up the previous row of trees completely!

Once you've reached the other side of your painting, let everything completely dry!

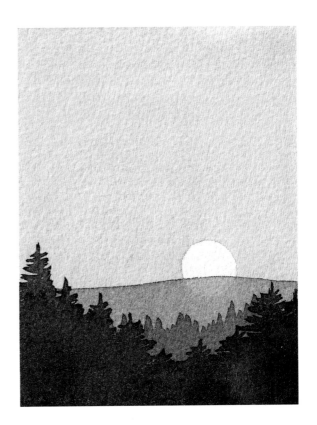

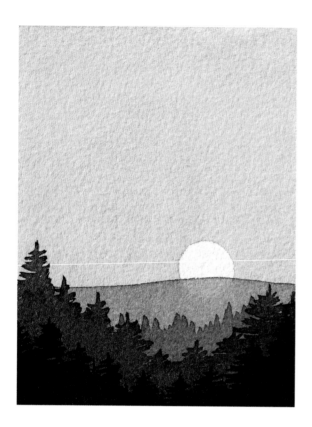

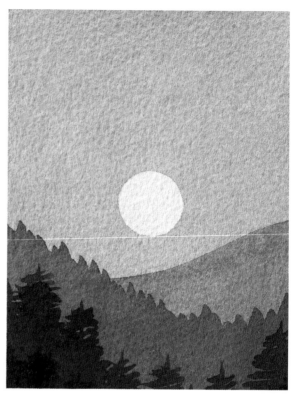

Step 6

Once everything is dry, you want to use the darkest value of your color possible.

Load your round brush up with paint and repeat the previous step, but this time place the trees slightly below the last row—as the trees get closer and closer to the viewer, they become darker at the same time.

Let everything dry completely, remove the tape and you're done!

Alternative 1

For this painting idea you can use any color you want that allows you to get as light or as dark as you want! Here I only used Prussian Blue and adjusted the paint-to-water ratio the same way.

Alternative 2

Here, instead of using only one color, I used Cadmium Yellow and Carmine Red. I mixed both together and diluted them with water until I got a light value of a nice peachy color. Now, since I'm using two colors, I added more and more of both colors to make the value darker. The closer the trees get to the viewer, the darker and the more red I made the color to create a beautiful transition from yellow-orange to red!

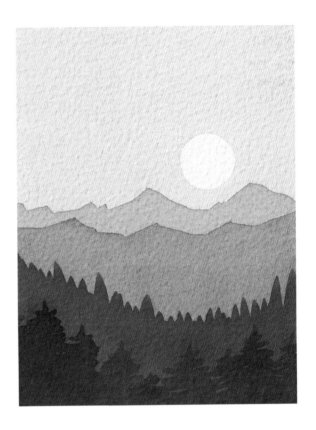

Misty Mountain View

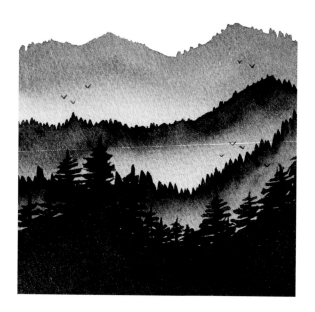

●○○ BEGINNER

Now that you're more familiar with creating distance in your painting, let's add another element to the landscape: fog and mist! The blending technique is not only great for softening hard edges, but also for spreading the paint to create a misty effect! In this painting, you're going to practice this blending technique as you create your own misty mountain landscape!

Materials you'll need

Masking tape

Watercolor paper

Size 8 round brush

Tissues or paper towels

Colors

 Payne's Gray

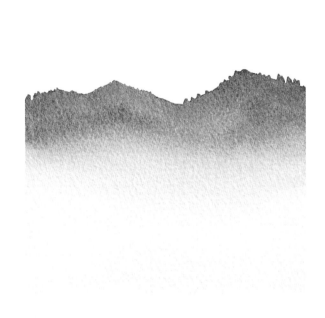

Step 1

Using masking tape, outline a rectangle on your watercolor paper and tape it down to your desk or board. If you use a base that allows you to tilt the paper, gravity will help you with this technique!

Now it's time to prepare the paint! Start by creating a big puddle of watery paint inside your mixing palette using just a little bit of Payne's Gray.

Next, load your round brush with paint and start applying it to the top third of the paper by creating a thick zig-zag line for the hills in different heights. Make sure the line is not too thin and not too thick or it will be more challenging to create a gradient effect from dark to light later. While you do that, you can use the fine tip of your brush to create small silhouettes of trees along this line as you move your brush across the paper. Clean your brush using water and a paper towel.

You want to work quickly! The drier the paint gets, the more difficult it is to fade it out! While the paint is still wet, use your clean damp brush and start softening the lower edges of the paint by following the contour of the wet paint. Just slightly touch the edge of the paint so the color moves into the damp area on the paper.

Once you've reached the other side of the paper, blend out the rest of the paint toward the bottom of the paper and then let everything dry completely. To speed up the drying process, you can use a hair dryer!

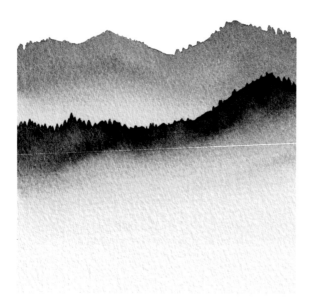

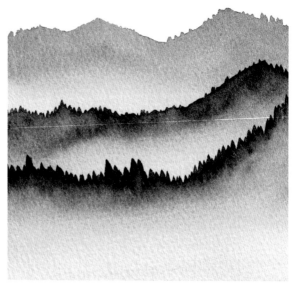

Step 2

Once everything is completely dry, add more pigment of the same color into the puddle to make the color value darker. Then you want to repeat the previous steps, but this time start creating another thick zig-zag line slightly below the first mountain so you can see the transition from dark to light.

Once you've reached the other side of the paper, place a clean, damp brush right at the edge of the thick line you just painted and start following the contour of the wet paint. Just slightly touch the edge of the paint so the color moves into the damp area.

Don't worry about making a perfect transition between dark and light. If you have uneven areas, even better, as this way your mountain will look less flat and more interesting! Once you've created the transition from dark to light, let everything dry completely again.

Step 3

As the mountains are getting closer and closer to the viewer, you also want to make the silhouette of the trees slightly bigger and darker. So once everything is completely dry, add a little bit more pigment to your puddle of paint (or create a new mixture if you ran out). From there, create another mountain slightly below the previous one.

Then use the shape of the tip of your brush to create the tree silhouettes. Hold your brush slightly parallel to the paper, so the tip is facing upward. Place the brush below the edge of the mountain and then press it down even more to make the shape slightly bigger. From there, fade out the paint the same way as you did earlier.

Once you've created the third mountain, let everything dry completely again.

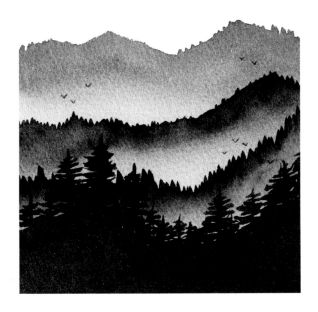

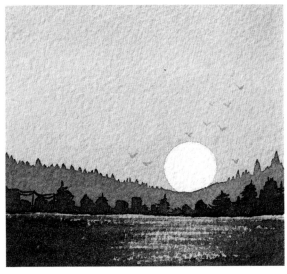

Step 4

Once everything is dry, it's time to paint the foreground of this painting.

This time, you can add additional silhouettes of trees that are now much more visible to the viewer so you can see their shape more clearly.

To create the trees, you want to add more paint to your puddle to make the color even darker.

Then, using your round brush, start at the left side of the painting and create a thin vertical line.

From there, starting at the top create a zig-zag shape that becomes wider and wider. This way you create another simple shape of trees that looks a little bit more realistic.

Don't worry about making them super-perfect; you just want to create an illusion of trees without getting lost in all the details!

You don't want to place the trees in one line, otherwise the painting will look boring. Switch it up!

If you want, you can also paint a few simple v-shaped silhouettes to add birds to your painting. This will enhance the atmosphere even more!

Once you've reached the other side of your painting, let everything completely dry, and you're done!

Alternative

Another idea is to add the moon or the sun behind the mountains by applying a flat wash of paint and lifting out a circle of paint with a coin as in the earlier projects!

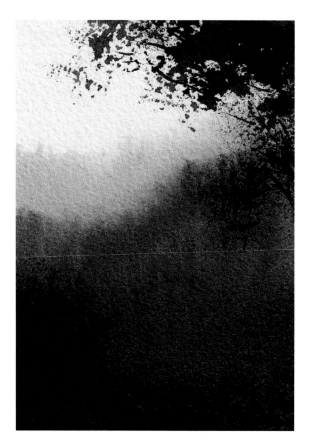

Gloomy Mountains

●●○ INTERMEDIATE

As you've learned in this book, when you paint wet-on-wet, the objects that you paint will have soft and fuzzy edges. Now the key to making this technique work is to make sure that the consistency of your paint is not too watery. The more watery it is, the less control you'll have, as the paint will just spread out and keep spreading. You can use this technique not only to blur out the background, but also to turn it into a glowy or, in this case, a gloomy and misty atmosphere! With this painting project, you're also going to practice your water and paint control even more as you create depth and details in your painting using only two colors!

Materials you'll need

Masking tape

Watercolor paper

20mm flat brush

Tissues or paper towels

Small piece from a sponge

Size 8 round brush

Colors

 Ultramarine

 Payne's Gray

Step 1

Using masking tape, outline a rectangle on your watercolor paper and tape it down to your desk or board. This will be the working area of your painting. Now it's time to prepare the paint!

Create a small puddle of water in your mixing palette and add a little bit of Ultramarine to the water to create a light value of this color. Remember, watercolors look lighter when dry, so try to adjust the color to make it slightly darker than it should ultimately appear!

Once you've prepared the color, go ahead and distribute the paint all over the paper using your flat brush. Move it from left to right and from top to bottom to evenly apply the paint. If you see any pools of paint on the paper, soak them up with a damp brush or a tissue.

Without waiting for the paint to dry, move on to the next step!

Step 2

Once you've applied the first wash of paint, it's time to use the wet-on-wet technique to create the blurry and gloomy effect for our mountains. For this step, add a little bit of Payne's Gray to the puddle of paint that you prepared earlier to make it darker and more concentrated. If you notice your color mixture is too watery, don't worry! Simply transfer a little bit of the paint to a new area of your mixing palette and add a little bit more Ultramarine and Payne's Gray to make the consistency creamier.

Once the wet paper has slightly lost its shine, load your flat brush with paint and remove any excess moisture from your brush by gliding it over the edge of your mixing palette.

Now quickly apply the paint horizontally around the upper third of the paper to create the outline of the first mountain. To make it more interesting, change up the height and add small thin lines across the edge using the tip of your brush. Once you've reached the other side of the paper, fill out the lower part of the line to cover everything in paint.

Without waiting for the paint to dry, move on to the next step!

Step 3

The next mountain is closer and more visible to the viewer. That's why we want to make the color even darker and more saturated.

This time you want to add even more Payne's Gray to your mixture to make the value darker and the consistency of your paint even creamier. Swatch the color on a separate piece of paper to make sure the color is darker.

Again, you don't want to add additional wet paint on top when the paper is still super shiny, otherwise the color will spread out too much.

Then you can apply the paint the same way as in the previous step, just slightly below the first mountain.

Once you've created the second mountain, let everything dry completely. To speed up the drying process, you can carefully use your hair dryer.

Step 4

When everything is completely dry, the color of your Payne's Gray can slightly change. Mine turned from being bluish to just gray and black. And that's okay!

Now you want to add the foreground of the gloomy mountains by creating trees using the darkest value of the Payne's Gray and a piece of sponge!

For this step, dip the edge of your sponge into your water, squeeze it out so it's not too wet and dip it into a creamy mix of the darkest value of Payne's Gray.

From there, start lightly dabbing on the texture of the sponge to the upper-left and lower-right side of the painting. For this design, think of the trees as fireworks. Apply more paint to the crown of a tree and space out the texture as you move to the sides.

From there, load your round brush with a dark value of Payne's Gray, and then use the tip of the brush to paint thin lines in between the leaves. This way, you create a few simple branches in between.

Let everything dry, and you're done!

Alternative 1

You can also use only one color as I did it here! In this painting, I only used Payne's Gray and its different values. In the end, I added the darkest value for the foreground to create simple silhouettes of trees.

Alternative 2

Or you can also combine different techniques! For the first two layers, I used Ultramarine and lifted off the wet paint using a coin wrapped in a tissue. From there, I added more layers using a concentrated mixture of Ultramarine and Sap Green.

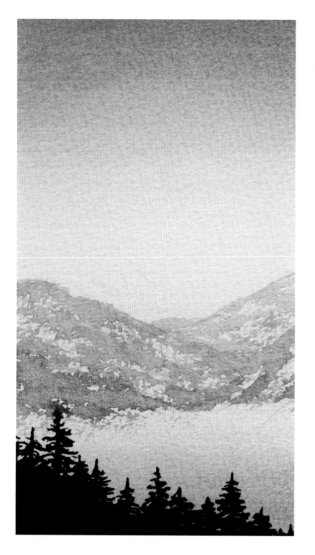

Sunset Snowy Mountains

● ● ○ INTERMEDIATE

Painting snowy mountains doesn't have to be difficult! A simple way to create mountains in no time is by using the dry brush technique, the same way as in the Cloudy Starry Night Sky on page 99. In this painting project, you're going to continue practicing different washes as well as adding details to your painting that will make the whole scene come to life!

Materials you'll need

Masking tape

Watercolor paper

20mm flat brush

Tissues or paper towels

HB pencil

Size 8 round brush

Colors

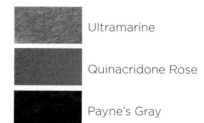

Ultramarine

Quinacridone Rose

Payne's Gray

Step 1

Using masking tape, outline a rectangle or square on your watercolor paper and tape it to your desk or board. This will be the working area of your painting. Then it's time to prepare the paint!

Create a small puddle of purple paint of concentrated consistency using Ultramarine and Quinacridone Rose. Next, load your flat brush with clean water and evenly distribute it all over the paper. If you see any pools of excess water, soak them up with a damp brush or a tissue.

Then load your flat brush with the purple color and create a graded wash by starting at the top of the paper, while moving your brush from left to right, back and forth. If you notice that you still have too much paint on your brush, simply rinse it, dab off the excess water and then use the moisture on the brush to blend out the rest of the paint on the paper. Once you've reached the center, repeat the same step starting from the bottom of the paper.

While the paint is still wet, move to the next step!

Step 2

Load your damp brush with a little bit of Quinacridone Rose and apply it right to the center of your paper and distribute it by moving your brush from left to right, back and forth, while also moving it up and down to blend the red into the purple-colored layer.

When we add the mountains on top later, this color automatically will make the mountain look warmer and more glowy.

Once you've blended in the second color, let everything dry completely.

Step 3

Now it's time to add the mountains!

For this step, let's plan out where they'll go on our painting. Once the layer of paint is completely dry, use your pencil and lightly draw a diagonal line across the center of the paper from left to right and then another line from right to the center of the first line.

Now instead of simply painting mountains using flat washes as in the previous paintings, you can use the power of a dry brush to add not only texture to the mountains, but also to make it look as if there is snow on top of them!

Create a light value of the purple color that you prepared earlier. Load your brush with paint and make sure the brush is dry enough before you apply it to the painting. This means you should hold your brush slightly slanted toward your swatching paper and quickly brush it over your scrap paper to test it (page 36). You know the brush is dry enough if you see white spots of paper shining through the paint. If you move your brush quickly over the paper, the paint won't have enough time to sink into the texture and will leave white spots behind. If you don't see them, soak up the excess moisture using a paper towel.

Now all you want to do is lightly brush over the right outline of the mountain from left to right.

You want to have some areas covered in paint, but also some areas that are still white.

Step 4

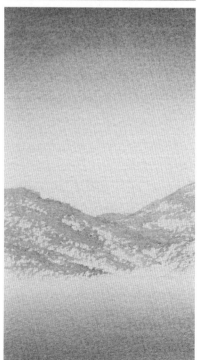

Now you want to repeat the same step for the left mountain. This time add a little bit more Quinacridone Rose to the puddle of paint to make the value darker, as this mountain will be slightly closer to the viewer and show more contrast.

Move your brush from the top corner of the outline to the lower right to make it look like the mountain has multiple hills.

You can also use the tip of your brush to lightly brush over the paper to create thicker diagonal lines in order to create areas on the mountains that don't have snow on top.

Let everything dry completely again.

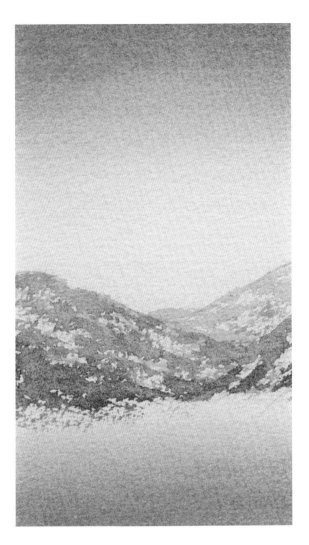

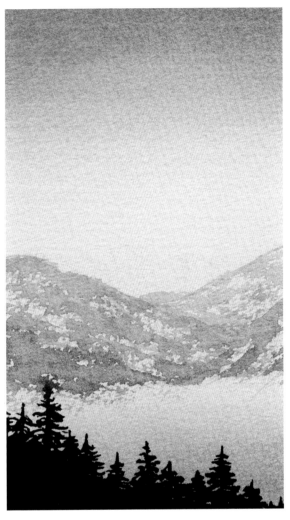

Step 5

To add even more depth, brush another layer of the same color on top. As you layer both colors, you'll create a darker value.

Step 6

Now it's time to add the trees!

To create the trees, load your round brush with water and Payne's Gray. To make sure the tip of the brush is fine enough, remove excess moisture by gliding your brush over your mixing palette.

Then, start at the lower-left side of the painting and create a thin vertical line using your round brush. From there, starting at the top, create a zig-zag shape that becomes wider and wider. Again, you don't want to place the trees in one line or the painting will look boring. Switch it up!

Once you've reached the other side of your painting, let everything dry completely and you're done!

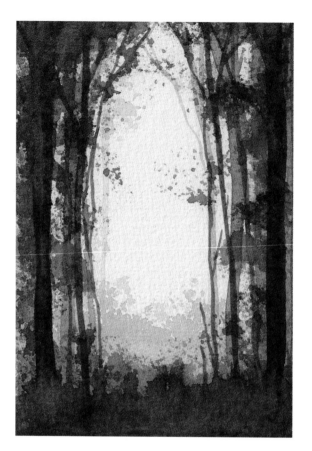

Enchanted Forest

●●○ INTERMEDIATE

With the Ocean Cave painting (page 57) in the beginning, you overlap different shapes using different values to create a mysterious atmosphere, making the viewer feel as if they are about to discover something interesting hidden deep in the cave. Using this same technique, you can use the transparent beauty of watercolors and their layering ability to create a beautiful forest scene. Let's do it!

Materials you'll need

Masking tape

Watercolor paper

20mm flat brush

Tissues or paper towels

Size 8 round brush

Small piece of a sponge

Colors

 Lemon Yellow

 Ultramarine

Step 1

Using masking tape, outline a rectangle on your watercolor paper and tape it down to your desk or board.

Now it's time to prepare the paint!

Start by creating a big puddle of water in your mixing palette.

To make the forest look bright in the background, you want to create a light flat wash of Lemon Yellow, so add a little bit of Lemon Yellow to the puddle to dilute it.

Remember, in watercolor painting, the more water you use and the less pigment you add, the lighter the color becomes.

Test the mixture to see if it's too light or too dark. Remember, watercolors look lighter when dry, so make the first wash slightly darker than it should ultimately appear.

Next, load your flat brush with paint and apply it all over the paper. Move your brush from left to right, back and forth and up and down. Once you've distributed the paint all over the paper, remove any puddles of excess paint by soaking them up with a damp brush or a tissue.

Then let everything dry completely. To speed up the drying process, you can also use a hair dryer!

Step 2

Once everything is dry, it's time to layer the first rows of trees!

To make a less vibrant green, add a little bit of Ultramarine to the Lemon Yellow mixture. Next, load your round brush with paint and remove any excess moisture by lightly gliding it over the edge of your mixing palette.

From there start painting a few thin vertical lines around the center and on the sides. Don't paint too many, as you will add more trees later anyway! Just make sure the lines are thin to create the illusion of distance.

After that, dip your sponge into the paint mixture and squeeze out any excess water. Now you can press the edge of the sponge down to create the leaves. Change up the pressure and how you hold the sponge to create different types of loose textures. You can also add texture to the lower part of the painting to create new small bushes in between the trees as in the example.

Once you've painted a few trees, let everything dry completely!

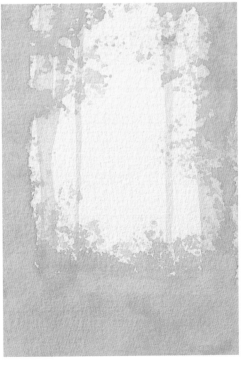

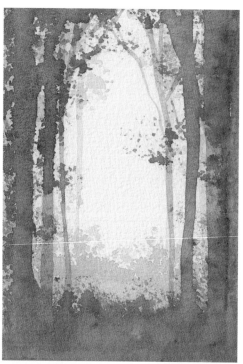

Step 3

Once everything is completely dry, repeat the previous steps!

This time, add slightly more Ultramarine to your mixture to create a darker value of green-colored paint. If you run out of color after finishing one row of trees, don't worry! You can always create another small puddle of water and re-mix new paint!

Then, load your round brush with paint and create another row of trees.

Even though small, soft shapes are in the background to create the illusion of depth, you can still play around with different sizes in the foreground!

In this case, I painted a thicker, darker line for the second row of trees and placed a few thinner lines in between.

Next, using your round brush and the same color, paint a few softly bent lines to create a few additional smooth, flowing branches.

After that, use your sponge again to dab on a few loose leaves around the branches and around the lower edge of the painting.

As you can see, my paper here dried really quickly in the process, and the paint dried a little bit patchy. If this happens to you as well, don't worry! This actually adds more texture and makes the forest look more interesting.

Step 4

Once the previous layer of paint has dried, add the last row of trees.

This time, use an even darker value of green-colored paint by using more pigment than water to mix your paint.

Place the additional trees somewhere in between the previous layer so all the other trunks are visible as well.

Once you've added a few additional branches and leaves, you're done!

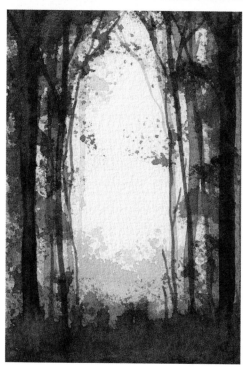

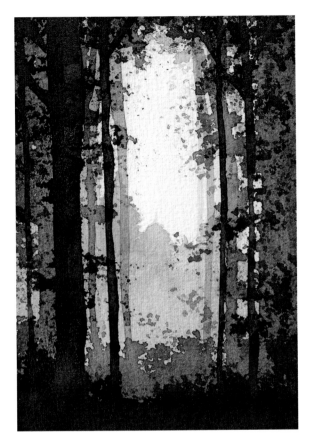

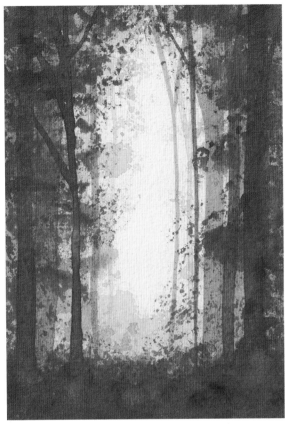

As always, you can play around with different colors! Different colors can convey different atmospheres and moods. Use one or two colors and overlap them!

Alternative 1

Here I only used Payne's Gray and layered one wash of paint at a time. Instead of keeping the background empty, I also painted a few additional silhouettes of trees!

Alternative 2

Here I used Cadmium Yellow and Carmine Red to create this forest. By changing up the color, the whole atmosphere changes from dark and gloomy to warm and even autumn-like!

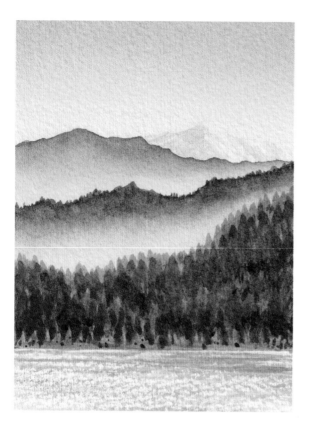

Sunny Mountain Lake View

●●● ADVANCED

With this painting project, we're not going for realism. The goal is to practice your watercolor painting skills by using different wet-on-wet painting techniques to create this artwork!

Materials you'll need

Masking tape

Watercolor paper

HB pencil

20mm flat brush

Size 8 round brush

Tissues or paper towels

Colors

Cerulean Blue

Ultramarine

Yellow Ochre

Payne's Gray

Step 1

Using masking tape, outline a rectangle on top of your watercolor paper and tape the paper to your desk or board. This will be the working area of your painting. Now it's time to prepare the paint!

Lightly sketch out the different mountains using an HB pencil following the guidelines.

Following the rule of thirds, the sky will be in the first third, the misty mountains in the second third, and the mountain covered in trees will be in the lower third.

But before starting to paint in the next step, let's prepare the paint first!

Mix Cerulean Blue and Ultramarine together in your mixing palette to create a concentrated mixture. This is going to be the top half of the sky. Because a cloud-free sky is actually rarely just blue, you want to add some sunny warmth to it as well. For this step, create a small puddle of water in your mixing palette and add a little bit of Yellow Ochre to it. You want to create a very light value.

Step 2

Now load your flat brush with water and apply it to the top part of the paper all the way down to the second mountain to create the base. Make sure to soak up any puddles of water that might be gathered around the edges.

Then load your flat brush with the paint you just prepared and start distributing it, starting at the top. You want to move your brush from left to right, back and forth as you move your way downward to create a graded wash. If you notice the color doesn't become lighter as you go, rinse your brush, dab off excess water and use the damp brush to blend out the rest.

After that, load a clean brush with a light value of Yellow Ochre. Begin distributing it, starting on top of the mountains. Move your brush from one side to the other as you move upward to lightly blend the Yellow Ochre into the blue sky.

If you see a harsh line from the Yellow Ochre around the mountain area, use the blending technique (page 34) to soften the edges! Rinse your brush, dab off excess water and blend out the hard edge toward the bottom using your damp brush.

Then let everything dry completely.

Step 3

Once the first layer of paint is dry, it's time to create the first mountain covered with snow!

For this step, we're going to use the dry brush technique again (page 36), so dab your dry round brush into the blue color you used for the sky and remove any excess moisture from the brush using a tissue. Test it out on a separate piece of paper to make sure the brush is not too wet or too dry.

Then you can start forming the mountains using the dry brush technique. Begin by brushing the pigment over the left side of the mountain. Start at the left side and move your brush upward toward the tip. This side will be darker.

After that, repeat this step, but this time move the brush starting at the tip of the mountain while moving the brush diagonally toward the second mountain below.

In this way you will create diagonal lines that form the shape of the mountain.

Then let it dry!

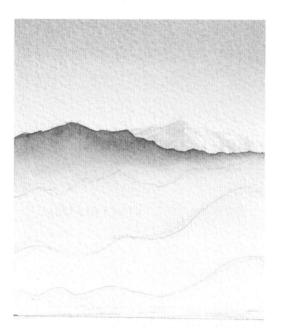

Step 4

As the mountains are getting closer and closer to the viewer, you want to make the colors more saturated and add more contrast.

For the second mountain, we're going to create a misty mountain using a concentrated mixture of Cerulean Blue and Ultramarine.

Load your round brush with paint and distribute it along the outline you created. Make sure the line is not too thin, as you want to drag down the paint later with a damp brush to create the misty effect.

Once you've reached the other side of the paper, rinse your brush and remove some of the excess water. Then use your damp brush to pull the paint downward by placing the brush next to the edge of the color while you move the brush to the side. This step is the same as with the Misty Mountain View painting (page 140).

To make sure the paint doesn't dry with a harsh line on top of the lower mountains, use a clean brush to blend out the rest of the very light value of paint toward the bottom.

Then let everything dry completely again.

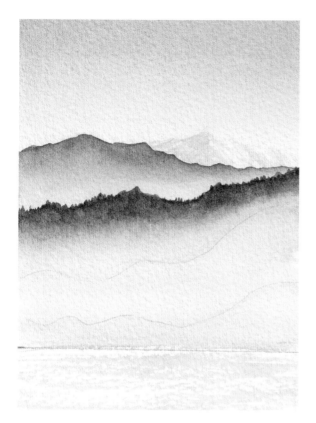

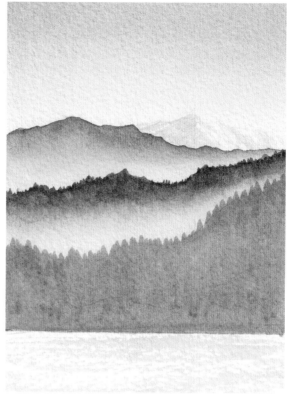

Step 5

The next mountain is even closer to the viewer. This time let's make it slightly warmer by slowly introducing warm greens!

This time you want to add a little bit of Yellow Ochre to your mixture of Cerulean Blue and Ultramarine to create a warmer shade of green.

From there, repeat the same step as you did with the previous blue mountain and let everything dry completely again.

As the mountain is drying, use the same color to create the water reflection using the dry brush technique.

For this step, load your brush with a little bit of paint and make sure the brush is relatively dry by soaking up some of the excess moisture. Then lightly brush the color from one side to the other below the horizontal line. This way you get some simple water reflections.

Step 6

When everything is completely dry, it's time to create the mountain filled with green trees!

This time you want to use a lot more Yellow Ochre and add it to your previous color mixture. This way your greenish-blue turns into a warm yellowish-green.

Create a creamy mixture, load your brush with paint and fill the whole area inside the guidelines to create the base for the trees.

This is going to be the lighter areas where the sun shines.

Then let everything dry!

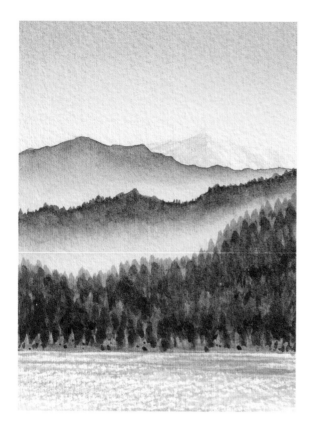

Step 7

Now it's time to add a variety of different trees on top of the hill.

For this step, use the same blue colors and mix them with different amounts of Yellow Ochre to create different shades of green. You can do this during the painting process!

Load your round brush with a slightly darker shade of green and start painting the trees the same way as you did the Mountain View on page 134 and Misty Mountain View on page 140.

Press the brush down and transfer its shape onto the paper to create the silhouette of a tree.

This time, instead of painting them in one row, leave out a few areas so you can clearly see the shape of the brush.

Then load your brush with a darker green and repeat the last step. These trees will add shadow and depth.

As your brush becomes more and more dry, use the remaining pigment on the brush to create another layer on top of the water reflection. This way you will create the reflection of the mountain the same way that you did earlier.

After that, you can use an even darker value of green to add a few dots and smaller trees here and there.

As you can see, I placed the darkest trees around the outline I created earlier, and in front of the water.

Let everything dry completely, and you're done!

What to Do Next

Now that you've gone through all the painting projects inside the book, you might have found some projects super easy, while others were super challenging. And that's okay! It means you're learning and growing! The more you practice, the better you'll get! Be patient!

The problem that we all usually have is that we tend to compare our art with other people's. We browse through the Internet and see all the beautiful artwork, but the thing is, we never get to see how long it took for someone to create it. We instantly assume it took this person a few minutes and they must be born with a special talent, when in reality it took them years of experience and a stack of multiple attempts before they could showcase their art on their highlight reel.

Remember, painting with watercolors isn't a competition. It's also not about focusing on the outcome or about creating a "perfect" painting. It's all about focusing on the present moment, enjoying the process and, most importantly, enjoying yourself!

The more you practice and give yourself permission to just play around with this medium, the more fun you'll have along your watercolor journey. You're right where you're supposed to be!

Now you might ask yourself, what should I paint next?

With all these techniques, tips and tricks, you have a great foundation you can build on to continue your watercolor journey with confidence.

Because there is only a limited amount of space, it was impossible to cover everything in this book. That's why I created additional projects and resources that you can use as you continue on your watercolor journey.

To get full access to all these valuable resources at zero cost, go to:

makoccino.com/watercolorwithconfidence

Acknowledgments

First, I wanted to thank my family, who—after trying to convince me to finally get a "real job"—let me do my own thing without doubting me ever again.

Thank you to all my close friends. Thank you for believing in me, pushing me and cheering me on whenever I was a hot mess!

Thank you to everyone on the Page Street Publishing team who helped me make this book a reality. My special thanks to Lauren Knowles, who made the whole process so collaborative and fun! Also an additional thanks to Meghan Baskis, who made sure we found the perfect cover!

Thank you to Jon Acuff for writing the book *Finish*. Whenever perfectionism and self-doubt crept in, I knew I could count on your words to get me back on track.

And last but not least, an immense thank you to all my followers. This book wouldn't have been possible without your questions, stories and constant support throughout this journey!

About the Author

Mako is a multi-passionate artist dedicated to helping people discover joy and their full potential in life through art. To fulfill that passion, she has been sharing painting tutorials, inspiration, tips and tricks since 2011 on her YouTube channel with an audience of almost 2 million people across over 186 countries.

Her talent is to turn complex theory into bite-sized information that everyone can follow. She is known for her step-by-step teaching approach that helps people learn how to paint and get confident, not only in their painting skills but also in themselves.

Mako loves cats, drinks way too much coffee and is devoted to always learning and growing as a person without being afraid to fail. Her motto is: You never lose. You either win or you learn. She also likes to occasionally channel her inner Beyoncé.

Index